SKIES & CLOUDS

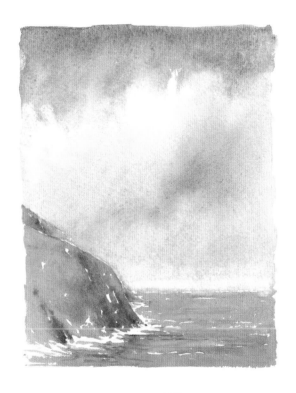

RICHARD TAYLOR

COLLINS & BROWN

First published in Great Britain in 2003 by
Collins & Brown Limited
64 Brewery Road
London N7 9NT

A member of **Chrysalis** Books plc

Distributed in the United States and Canada by Sterling Publishing Co.,
387 Park Avenue South, New York, NY 10016 USA

9 8 7 6 5 4 3 2 1

British Library Cataloguing-in-Publication Data:
A catalogue record for this book is available from the British Library

ISBN: 1-85585-815-0

Editorial Director: Roger Bristow
Project managed by Emma Baxter
Copy-edited by Katie Hardwicke
Designed by Alison Shackleton
Photographed by Ben Wray

Printed and bound in China

CONTENTS

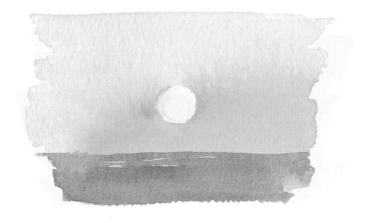

TOOLS AND MATERIALS

This book is designed to be a pocket 'field guide' that you can take with you as you explore the landscape and examine the areas of vast, open sky. Indeed, skies and clouds are particularly well suited to the watercolour medium, and for this reason this first chapter is devoted to examining the equipment that you will need to take out with you to get the most out of a painting expedition.

I find that watercolour sketchpads are invaluable for working on-site, especially the ringbound variety. They are light, easy to carry, and provide you with a hard-backed surface for supporting your painting. They are also available in a wide range of paper weights and sizes. My personal preference is for a 210 x 297 mm (8¼ x 11¾ in) or 297 x 420 mm (11¾ x 16½ in) pad with at least 300gsm weight water-colour paper. This is particularly strong paper which allows a lot of water to be applied without the paper 'cockling'.

A selection of pencils allows me to make a series of quick sketches of particular skies or clouds I find interesting. This includes B, 2B and 4B pencils, a couple of soft graphite sketching pencils, and a limited selection of water-soluble colour pencils – particularly useful for making very quick studies and also for strengthening some watercolour washes and softening lines that a brush will not always do. They are basically solidified

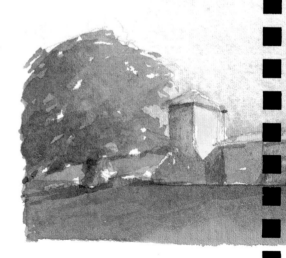

CALM EVENING SKY - WATERCOLOUR
The gentle, calmness of a summer's evening sky can be painted very quickly. Only two colours were painted across very wet paper until they met and were allowed to blend and dry to a graduated colour.

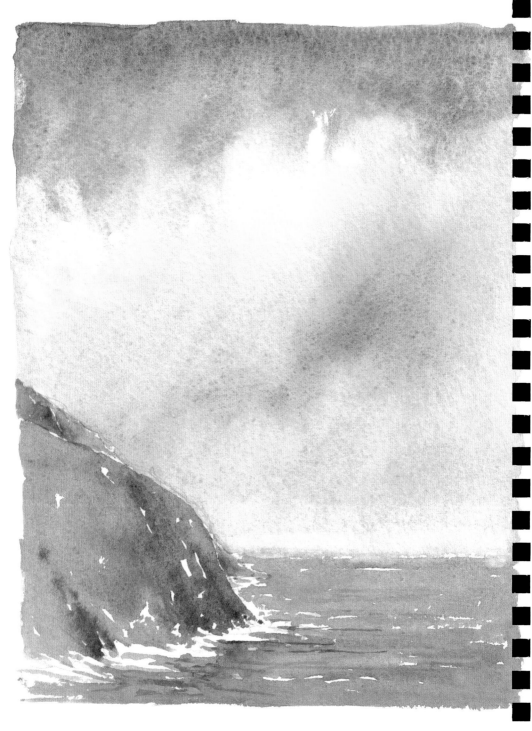

Pads and Sketchbooks

Watercolour and cartridge-paper pads are essential for outdoor use, because they are compact and allow you to keep all of your work flat and held together. They can be used for visual notes to remind you of the scene, and personal thoughts, as well as for more 'finished' paintings (which are rarely completed on-site).

sticks of watercolour pigment that create a series of highly textured marks when used on watercolour paper. Their great advantage is that they can be sketched with and then washed over with water – this turns the pigment into watercolour paint – or used as pencils onto wet paper, immediately providing greater strength of colour.

I also carry a set of paints, brushes and a water container. The most interesting painting sites are often in remote places, and so I find that creating a basic painting kit is a very valuable exercise. Pare your requirements down to the minimum.

On location, I carry a small watercolour tin which contains a set of twelve pan paints (these are all favourite colours that I have come to settle with after several years of experimentation). The great advantage of these portable pan sets is that they provide a ready-made mixing palette (usually in the lid) and often also contain a small retractable brush.

On the subject of brushes, I like to carry a limited set of three: one large for underwashes, one medium for applying wet washes onto wet paper and one small for applying details, usually onto dry paper. For

Cloud Study – Water-soluble Pencils

Whilst coloured water-soluble pencils are not best suited to sketching whole sky scenes they are, however, very useful for making small cloud studies (right), capturing the shape and key colours very quickly.

Atmospheric Sky – Watercolour

The variety of tones of blues, violets and yellows witnessed in atmospheric skies (left) are highly conducive to recording in watercolour paints – just wash them onto wet paper and allow them to dry softly.

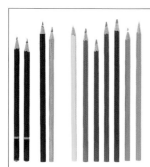

TRAVELLING LIGHT

A few selected pencils are a valuable asset to your sketching kit – carrying too many only complicates matters, as you have to think about which ones to use. Graphite pencils come in a variety of grades. Artists usually make use of the B (soft) grade pencils: 6B is the softest and gives rich, dark tones, while B is the lightest and offers a subtle range of greys.

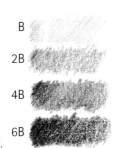

B

2B

4B

6B

WATER-SOLUBLE GRAPHITE PENCIL STUDY

The images and shapes viewed directly against the sky can be recorded quickly 'on-site' using water-soluble pencils – especially at either end of the day when the fading light often reduces shapes to soft grey tones.

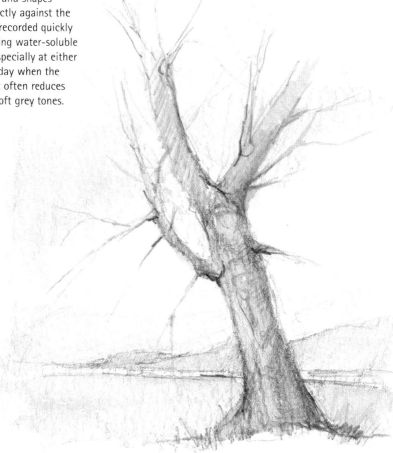

outdoor expeditions I usually buy synthetic brushes. These are a perfectly acceptable alternative to the more expensive natural-hair brushes, and losing them (a frequent occurrence) is nowhere near so costly. However, for studio painting I do prefer to use pure sable brushes. All of the brushes I use for painting skies and clouds are round-headed, which makes them 'universal' in that they can be used in any style for any particular subject. I tend to use them by loading a brush with paint and applying this by dragging the brush across the textured watercolour paper - this could be dry or damp, depending on whether I want broken brushstrokes with flashes of white paper showing through the paint, or a soft bleed as the wet paint from the brush blends in with the damp paint already on the paper to create subtle, transitional tones without defined edges.

Finally, I always like to carry a small plastic water pot which clips onto the side of my watercolour tin lid.

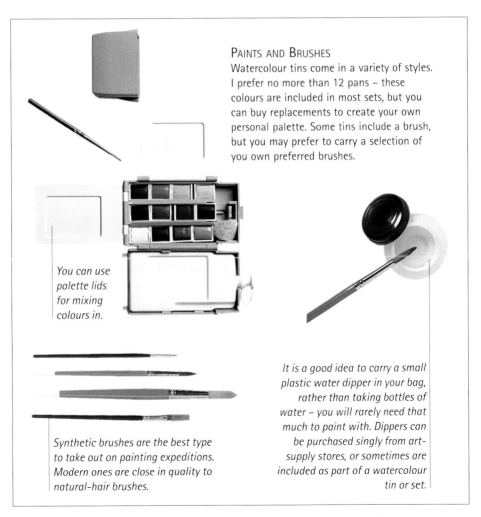

Paints and Brushes

Watercolour tins come in a variety of styles. I prefer no more than 12 pans – these colours are included in most sets, but you can buy replacements to create your own personal palette. Some tins include a brush, but you may prefer to carry a selection of you own preferred brushes.

You can use palette lids for mixing colours in.

Synthetic brushes are the best type to take out on painting expeditions. Modern ones are close in quality to natural-hair brushes.

It is a good idea to carry a small plastic water dipper in your bag, rather than taking bottles of water – you will rarely need that much to paint with. Dippers can be purchased singly from art-supply stores, or sometimes are included as part of a watercolour tin or set.

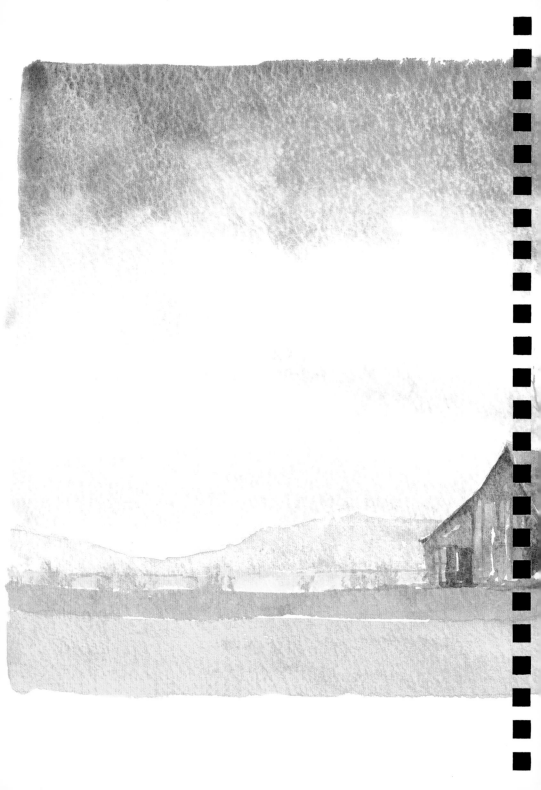

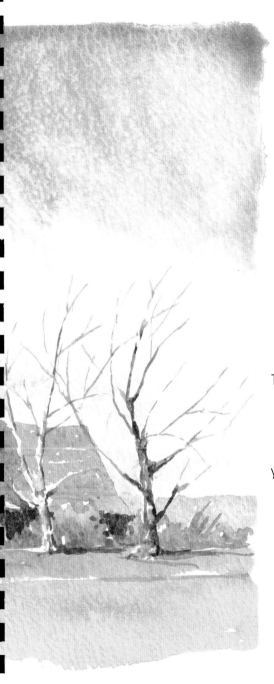

TECHNIQUES

The techniques for painting skies and clouds are as varied as the types of skies you are likely to witness in any part of the world.. This chapter, however, is concerned with a few of the 'key' techniques which, with a little practise, you will be able to master fully. Once you have done this you will be able to apply these techniques to any situation that you wish to paint, making it your own.

GRADUATED WASH

The clarity of a cloudless sky – or at least nearly cloudless – is best created by painting with a graduated wash. This is a wash which starts darker at the top of the paper, becoming lighter as it reaches the horizon. Whilst this effect can be achieved by applying one colour to wet paper and gradually 'washing' it downwards until the water on the paper has diluted the paint to a lighter tone, I personally prefer to use two paints – a darker blue on the top and a lighter blue at the bottom. For general sky studies my usual choice for these would be ultramarine and cerulean blue.

CREATING A GRADUATED WASH

1 First, damp the paper with clean water. From the base, wash cerulean blue up into the centre of the paper, using a smooth unhurried side-to-side motion.

2 Next, from the top of the paper, apply ultramarine and wash this downwards using the same motion as above. Allow the two colours to mix naturally.

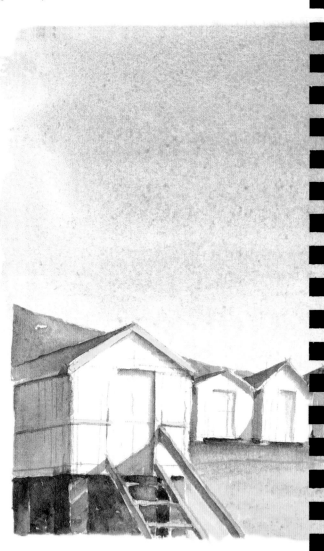

Wet the entire sky area evenly with a large brush and clean water. Once any puddles have gone, but ensuring that the paper is still wet, run a wash of watery cerulean blue (this is 'thin' and 'cold') along the horizon line and upwards to halfway up the sky area. Then apply a strong, watery application of ultramarine to the top of the page using horizontal, side-to-side brush-strokes and continue until the two colours meet. If you have worked quickly and applied enough water to the paper at the start, the two colours will blend, giving you a graduated sky with a pale horizon.

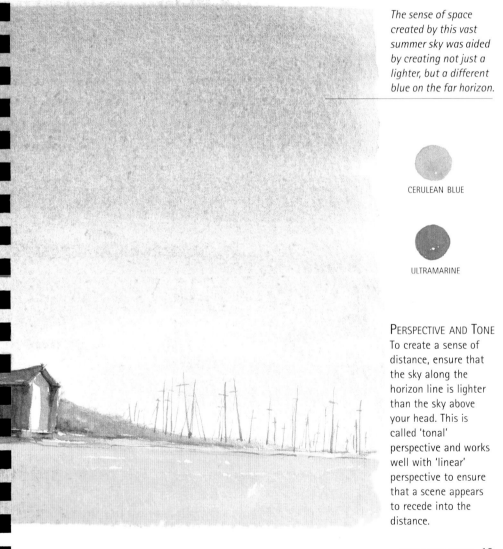

The sense of space created by this vast summer sky was aided by creating not just a lighter, but a different blue on the far horizon.

CERULEAN BLUE

ULTRAMARINE

PERSPECTIVE AND TONE
To create a sense of distance, ensure that the sky along the horizon line is lighter than the sky above your head. This is called 'tonal' perspective and works well with 'linear' perspective to ensure that a scene appears to recede into the distance.

FORMAT

Traditionally, artists have had to make a major decision before embarking on a painting – should they paint the subject on a 'landscape' (horizontal) or 'portrait' (vertical) format. Often the subject will dictate the answer, but this is not always the case. Most sky paintings suit a landscape format, however, it is worth experimenting with different formats, as the unexpected can often have much more visual impact.

Landscape is the traditional format for paintings containing large areas of sky or panoramic views, and has the advantage of allowing a wide angle vista to be painted, enhancing the feeling of open spaces. This format also allows more room for expressive brush work through vertical brushstrokes, but considerably more vigorous brushstrokes can be developed along the length of the horizon to record movement in clouds. Overall, the landscape format conveys a general feeling of calm and tranquillity.

The portrait format, however, can produce a much more exciting, visually dynamic composition. The height of this format allows a very 'high' view of towering clouds to be painted, enhancing the effect of 'pressure' on the horizon. This can often be used to dramatic effect when painting storm clouds or clouds with a great amount of 'height', allowing for more attention to be given to specific cloud shapes than an overall 'sky' view.

LANDSCAPE
The broad, landscape format is traditionally used by artists for expanses of sky and land.

PORTRAIT
This format, when applied to landscapes, is often used to add impact to the visual dynamics of the composition.

Positive and Negative Effects

Sometimes the colour value (the strength or lightness) of a sky is influenced by the objects in the immediate foreground of a composition – the darkness of a spring day can be enhanced by including white sheets blowing in the wind, for example – the light objects making the sky appear darker. Alternatively, a soft, hazy sky can be made to appear even lighter and more distant by including a dark tree in the foreground – the darker this is, the lighter and more distant the sky will appear to be.

ULTRAMARINE ALIZARIN CRIMSON

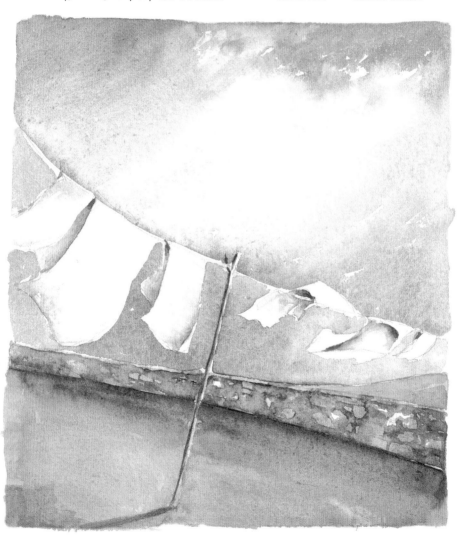

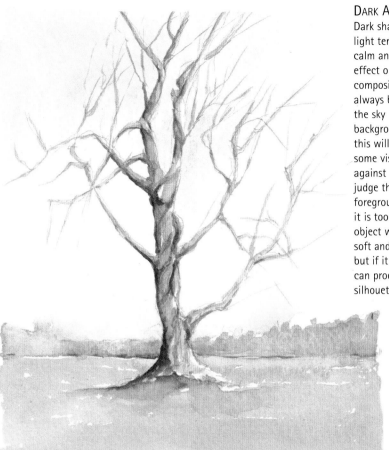

Dark shapes against light tend to have a calm and reassuring effect on a composition. It is always best to paint the sky and the background first, as this will give you some visual features against which to judge the tone of the foreground object – if it is too light the object will appear soft and undefined, but if it is too dark it can produce a silhouette.

COBALT BLUE

Negative shapes occur when the object in the foreground appears lighter than the background. Whilst it is possible to create these lighter shapes by applying masking fluid before overlaying a wash, it does produce shapes with unnaturally hard edges.

Light Against Dark

Light against dark is a tool that artists often use to create impact in their compositions. Objects, such as washing billowing or silver tree trunks – even white houses – are best left largely unpainted as the clarity of white paper is always sharper than white paint.

Even though painting around the lighter shape will disturb the natural flow of the sky, it is worthwhile in order to achieve softer edges. By first painting around the negative shapes with water will help to create a smoother application of colour.

Positive shapes stand out clearly against a sky, usually dominating the foreground with their presence. These shapes need to be painted onto dry paper as the sharpness of their form is critical to the success of the painting. Use a small brush and try not to overwork the shapes as this will diffuse the sharpness required.

BLOTTING AND SPONGING

Light clouds can either be created by leaving an area of white paper and painting around it, or by allowing paint to flood the entire sky and then removing some of the wash while it is still damp by sponging or blotting.

When you first look at your sky and begin to plan your composition, it is important to identify the size of clouds and exactly how much of the composition they will take up. Once you have done this, dampen all of the paper and apply the sky colours. These paints will run and bleed quickly, so make sure they are applied to the area directly around the clouds. Within seconds the sky colour will have bled into the tops and bottoms of the areas that you wish to make into clouds, so some of this paint will have to be removed.

Timing is important at this stage – if you wait too long the paint will have dried, but if you try to remove the paint too soon you will only remove the surface water, leaving the paint to bleed into the damp paper. Wait until a 'sheen' appears on the paper – this will tell you that the surface water has been absorbed and that the fibres of the paper are still damp and that any paint can now be soaked up or blotted accordingly.

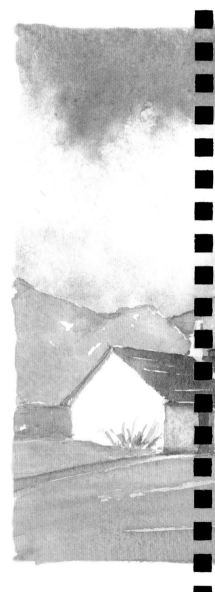

BLOTTING
Kitchen paper can also be used to remove wet paint, but this is much harsher and leaves very clear marks, making it more suited to creating moving, wispy clouds with definition.

SPONGING
Using a sponge to mop up, or remove, watery paint from watercolour paper leaves a soft edge around the sponged area and is suitable for creating summer clouds.

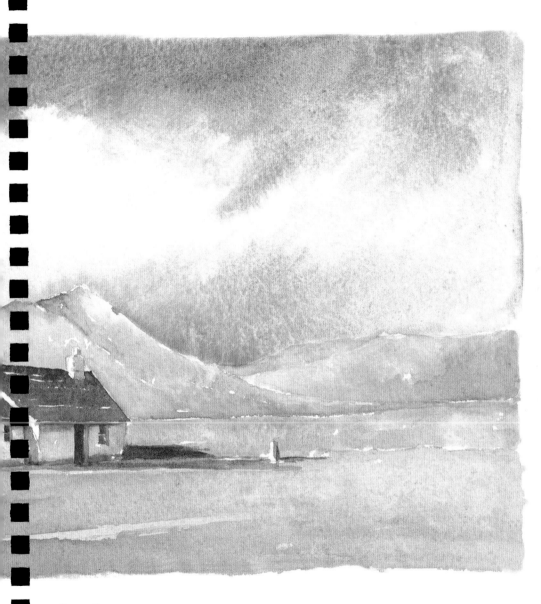

Cloud Shapes

The different types of clouds form a major part of this
scene. Although the differences are subtle – the larger
cloud on the left and the softer, hazy cloud on the
right – they are still very much a part of the sky.

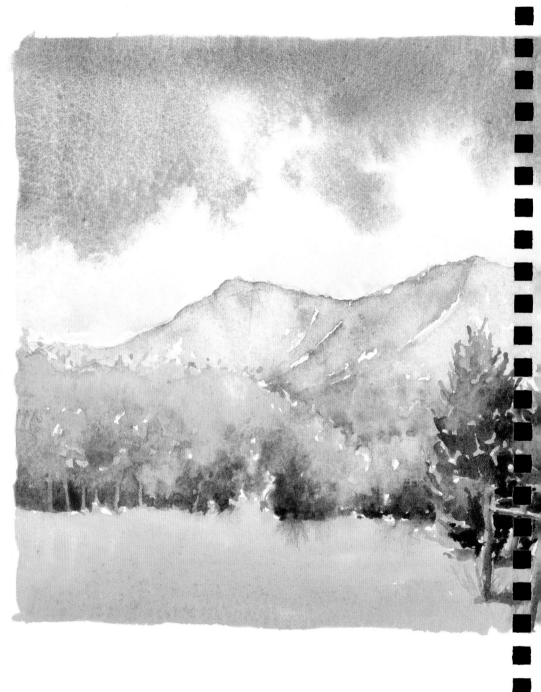

FINE WEATHER

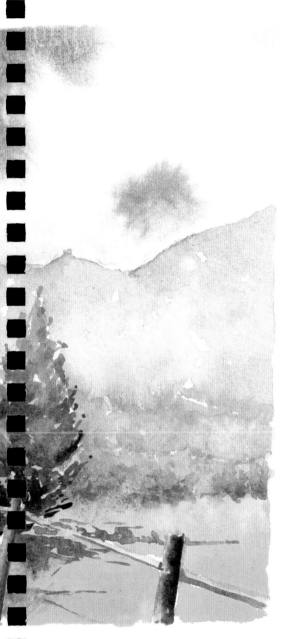

Few painters would disagree with the notion of fine weather painting. Sitting under an ultramarine sky with large, soft, white clouds building on the horizon and only a gentle breeze to rustle the foreground trees, is certainly a wonderful feeling to experience. For the watercolour painter this is an ideal time to set out on a painting trip to record the colours and calm of the peaceful scene.

Directional Wash

Even on fine, fair-weather days, you can find some degree of movement in the sky. This need not be due to gusting winds, but general air pressure and light breezes.

These skies are best painted by first applying an underwash of the key sky colour – on a fine day this will usually be a combination of ultramarine and cerulean blue. This paint mix should be applied as a graduated wash to wet paper and allowed to dry (see page 12). Once the whole sky is dry, the clouds can be painted on top of the

Using Colours

Colour can be used to suggest movement. Whilst too many colours in any one sky may be confusing, a number of tones of different colours can help to suggest high, thin clouds.

The strong ground colours are echoed by the deep colours and diagonal brushstrokes in the sky.

Diagonal Movement

A sense of movement can be created in skies by employing a diagonal, sweeping brush-stroke, easing off the pressure towards the end of the motion to gently release any paint remaining on the brush.

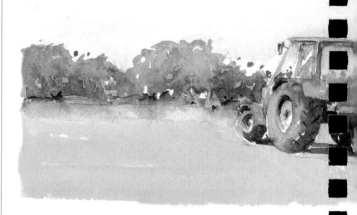

sky colours, using a watery wash of the cloud colour (Payne's grey and alizarin crimson in this picture), pulled in a diagonal direction from bottom left to top right. If you don't reload you brush with paint too frequently, you will be able to create some 'broken' brush marks which will allow the sky underwash to show through.

Finally, you can lighten certain areas by blotting with a piece of kitchen paper. This method suits the high wispy clouds, or mare's tails, of a summer's day.

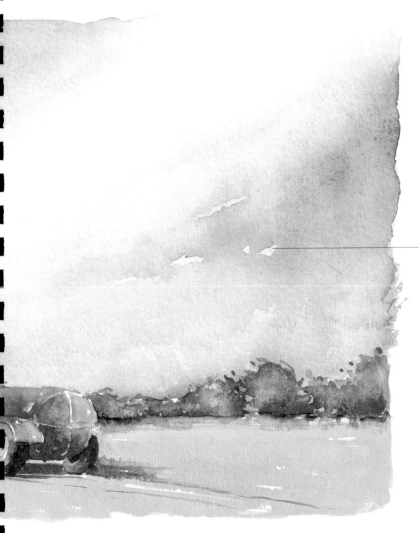

Where the clouds are painted over the underwash, it is particularly important to create a few breaks in the cloud to allow the underwash to show through, to add a sense of depth to the sky.

Using Yellows

The idea of 'atmospheric' skies is not something to necessarily associate with impending storms – fair weather days are equally capable of producing skies and clouds awash with appealing colours.

These skies can be painted considerably more effectively by introducing yellows into your palette. Whilst many yellows are suitable, the most useful is raw sienna – this is a 'natural earth' colour which has its origins in the foothills of the European Alps. Raw sienna can be used in two particular ways. First, as a soft wash on the far horizon. This needs to be applied to the sky immediately after the paper has been dampened, allowing the paint to bleed and dilute, softening its appearance. The second way to use raw sienna is as an underwash for clouds (see below). A second watery raw sienna wash applied to damp paper can be painted on top, allowing warm cloud tones to blend and soften while allowing the first sienna underwash to show through.

A soft wash of raw sienna, painted onto damp paper is very effective in creating a sense of far distance in skies.

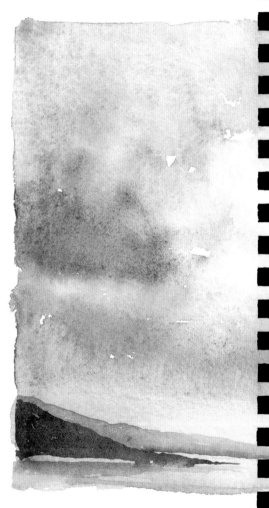

Yellows to Suggest Distance
Clouds hold subtle mixes of colour – always use plenty of water when painting studies such as this to allow the paints to run and bleed freely.

Yellows to Create Atmosphere

A sense of 'atmosphere' can be created by dropping a little yellow (quinacridone gold) onto damp clouds and allowing it to bleed and dry without interference.

The riot of colour in this sky could not have been ignored – yellows, golds, cool blues, warm blues and violets all sit easily together – this is the result of careful use of wet and damp paper.

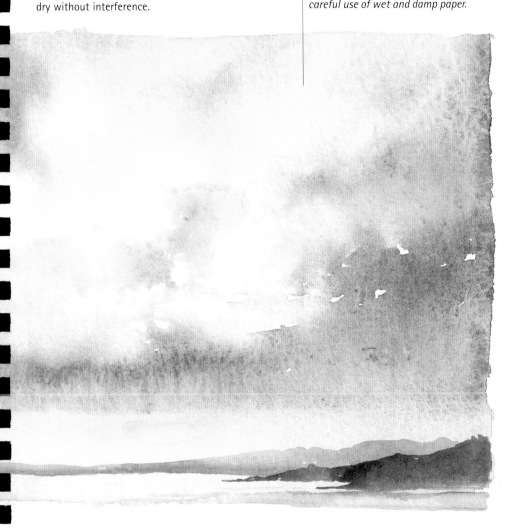

PAYNE'S GREY

CERULEAN BLUE

ULTRAMARINE

ALIZARIN CRIMSON

RAW SIENNA

QUINACRIDONE GOLD

FINE WEATHER CLOUDS

Fine weather, cumulus clouds are a wonderful feature of gentle, warm summer days and are highly conducive to recording in watercolour.

The first stage is to establish the approximate shape and size of the cloud. The best way to do this is to 'draw' around the shape of the cloud with a large water-laden brush, pulling the water out towards the edge of the composition. Then, before the paper has time to dry, apply a watery wash of ultramarine and allow this to flow freely on the damp paper.

Watercolour paint will not bleed freely onto dry paper so the cloud area will remain untouched and plain white. The next stage is to mix a watery wash of raw sienna and, using the edge of a large paint brush, paint this over the centre of the cloud. Should the paint around the edge of the cloud still be damp, then the paint will bleed a little – this will look quite natural.

The final stage is to quickly mix a little alizarin crimson with some ultramarine to create a soft violet and, again, using the edge of a large brush, wash this paint along the base of the cloud while the raw sienna is still damp. This will gently bleed, creating a little 'weight' at the base of the cloud, completing the process.

ULTRAMARINE

STAGE 1
Establish the basic sky colour first with a watery ultramarine wash.

ULTRAMARINE · RAW SIENNA

Stage 2

Add a wash of raw sienna before the sky has time to dry fully to allow soft edges to occur.

Stage 3

Add a final wash of alizarin crimson along the base of the cloud and allow it to bleed softly.

ULTRAMARINE · RAW SIENNA · ALIZARIN CRIMSON

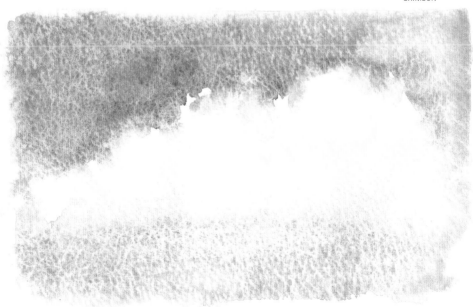

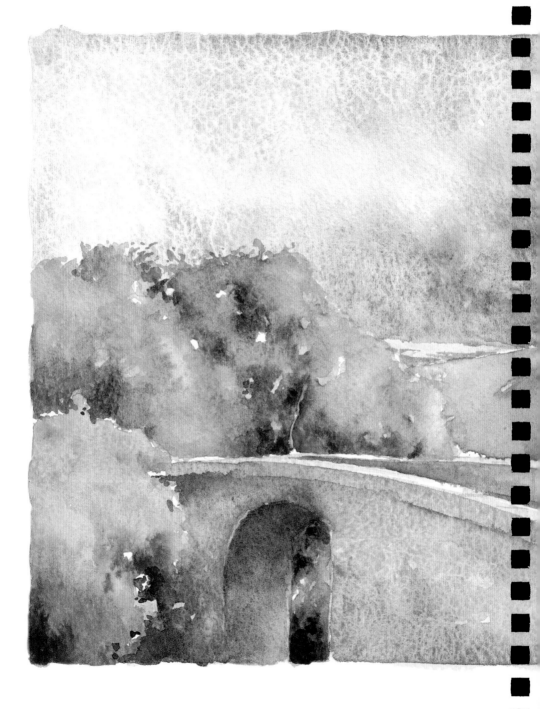

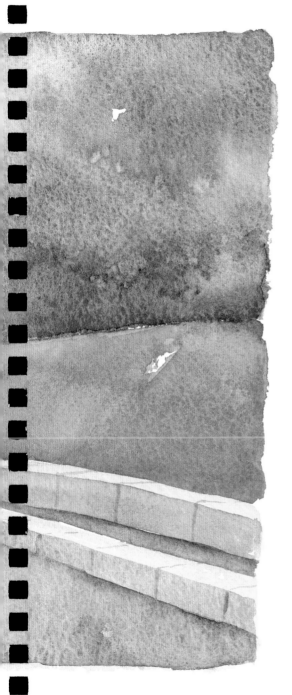

STORMY SKIES

The gathering of storm clouds on the horizon would normally send most people in search of shelter. For the painter, this is the very first sign of dynamic skies, clouds and compositions to come.

Painting stormy skies often enforces a sense of speed as the final outcome could mean getting wet – vigorous brushstrokes and wet-into-wet techniques with strong colours, will help to capture the drama of the approaching sky.

Vigorous Movement

Clouds moving rapidly from the far horizon to a much closer position to your painting site are certainly a reason for speeding up the painting process.

Using a large brush, mix a suitably dark cloud colour (burnt umber, ultramarine, Payne's grey and alizarin crimson). Ensuring that you have a lot of strong, wet paint, dip your brush into water, then into the mixture and apply it to dry paper, starting near the horizon. Pull the paint in a diagonal sweep across the sky. While the paint is still wet, apply some sky colour to the top of the composition and allow this to bleed into the cloud colour.

Once the cloud colour has dried, smaller clouds can be painted onto the paper using the edge of a medium size brush – should these dry with too hard an outline, they can be 'washed' in to the sky using just plain water, then blotting the edges to soften them more with kitchen paper.

Vigorous Brush Work
To create a sense of drastic movement in skies, it is sometimes necessary to employ rapid backward and forward brushstrokes to represent clouds in rapid succession. These brush strokes will blend if worked onto damp paper whilst still maintaining their vigour.

Composition
Pulling a strong wash of paint, using sweeping brushstrokes moving rapidly across the paper, is a good compositional technique.

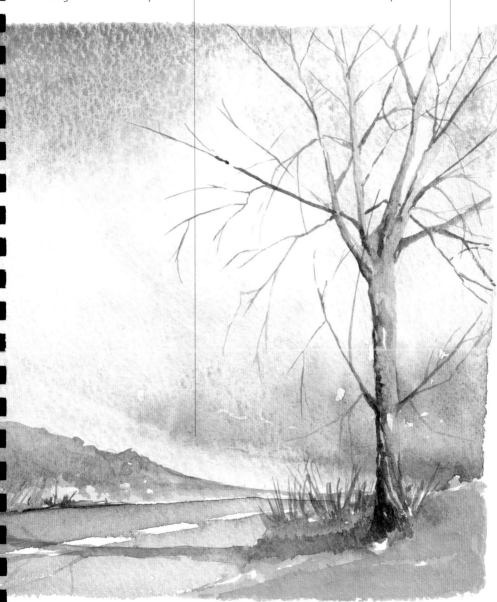

With a wind gusting across the landscape, clear and vigorous movement could be seen in the sky as the storm cloud on the horizon blew rapidly into the foreground of this composition.

Using 'broken' brushstrokes to paint skies and clouds can leave a few 'flecks' of white paper showing through. These can be particularly useful in creating highlights, visually 'punctuating' the tops of clouds.

Storm Clouds

Storm clouds are best painted using a cocktail of colours and plenty of water, allowing them to run, bleed and blend freely. The one most important consideration is to use greys mixed with colour and not pure black as this would have the effect of 'flattening' any scene.

First, wet the area of paper directly around the cloud shape. Before this dries, create a mixture of ultramarine with a touch of burnt umber and apply it freely. As this is drying, mix a watery wash of raw sienna and apply this to damp paper and let it run upwards towards the sky colour. Allow a few flashes of white paper to act as visual 'punctuation' marks or highlights at the top of the clouds.

Next, mix some alizarin crimson with Payne's grey and run this along the base of the cloud, encouraging the colour to run upwards into the still damp cloud by using the edge of the paint brush to 'pull' the paint in the right direction.

The final stage is to re-dampen the cloud and to apply assorted colour mixtures to this area. Using the tip of the brush will allow you to achieve intense areas of colour, with bleeds around the edges, suggesting the shadows that are to be found in cloud shapes.

ULTRAMARINE BURNT RAW
UMBER SIENNA

Stage 1
Establish the sky colour and apply a watery wash of raw sienna to the cloud area.

ULTRAMARINE	BURNT UMBER	RAW SIENNA	PAYNE'S GREY	ALIZARIN CRIMSON

STAGE 2
Before the raw sienna underwash dries, apply the other colour mixes using a lot of water.

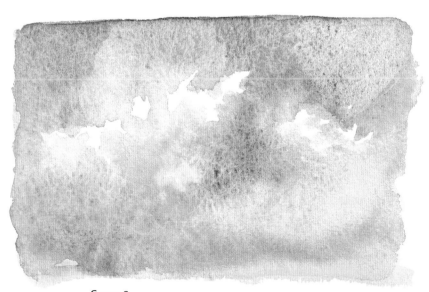

STAGE 3
Increase the depth of tone by using the same colours as Stage 2, but increasing their strength in key areas.

MIXING GREYS

The greys likely to be witnessed in skies and clouds need to be mixed without the use of black and white. Black will 'flatten' a colour and prevent any depth being created in the sky. White will simply form a layer over the white of the paper, diffusing its 'sparkle'.

Ultramarine is a good base colour when mixing greys to use on skies and clouds. Adding a range of colours to this 'universal' blue will produce countless greys, all of which can be diluted to further create an even wider variety of tones.

Burnt umber, for example, will produce a 'mid grey' which can be used in most skies and clouds. The addition of alizarin crimson will 'warm up' this mixture considerably as well as producing a grey with more 'depth' of tone. Raw sienna, when added to

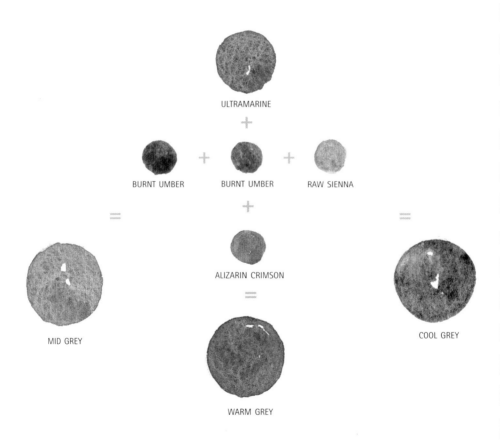

ULTRAMARINE

+

BURNT UMBER + BURNT UMBER + RAW SIENNA

+

ALIZARIN CRIMSON

MID GREY

WARM GREY

COOL GREY

ultramarine, however, creates a particularly 'cool' grey.

Payne's grey is a manufactured colour which produces a 'thin' blue-grey paint which dries to a very disappointing hue – it looks strong when wet, but dries to a considerably lighter tone. Payne's grey is rarely used in skies and clouds on its own. It is very useful, however, as a 'mixer' and can be used to create a range of blue-greys and brown-greys.

Whilst the colour mixes illustrated here are, probably, the most useful for painting skies and clouds, they are by no means exclusive. I strongly recommend that you experiment a little and try your own grey mixes. Try to create some different colour 'temperatures', some warm and some cool.

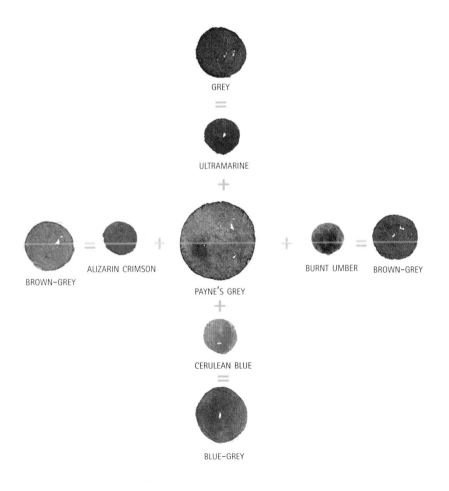

GREY

ULTRAMARINE

BROWN-GREY ALIZARIN CRIMSON PAYNE'S GREY BURNT UMBER BROWN-GREY

CERULEAN BLUE

BLUE-GREY

Masking Fluid

The first signs of an early winter's snow are always to be found in the sky. Darkening skies with tobacco-tinged clouds often herald the fall of the first white snowflakes.

These can be recorded very effectively by the application of masking fluid – a water repellent rubbery solution. It contains an element of ammonia and dries rapidly – only use old brushes or toothbrushes to apply it to your paper.

To create the effects of snowflakes, use an old toothbrush to flick the masking fluid

Using Masking Fluid

1 First, dip an old toothbrush into masking fluid, angle the head, and flick the rubbery solution across your paper.

2 When the masking fluid has dried, gently wash your first coat of paint across the paper – taking care not to dislodge any dried spots of masking fluid. You can now apply as many colours as you wish as the paper under the masking fluid is fully protected.

Applying very wet, watery paint to paper awash with surface water will create bleeds as the paints dry, suggesting moisture in the clouds.

An unexpected flurry of snow brings an entirely fresh appearance to skies, imposing a new method of recording – creating numerous white flecks by the application of masking fluid.

Use of Yellows
The addition of raw sienna to very wet paint will help to create a stormy atmosphere and break the potential monotony of a single tone of grey.

across the paper. Wait until this dries and then paint freely over the fluid, using as much water as you feel confident with as it will not penetrate the dried masking fluid.

It is imperative that you wait until the paper is completely dry before removing the masking fluid – if the fibres of the paper are even slightly damp, the rubber solution will stick to it, removing the surface of your painting. When it is fully dry, rub over the surface of your painting with a putty rubber to reveal a spattering of tiny white dots.

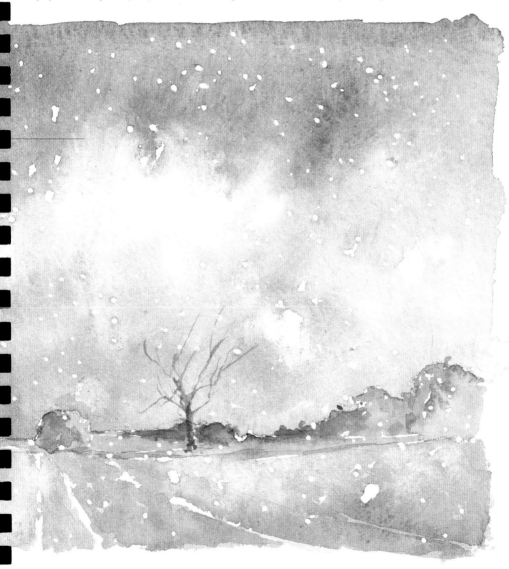

Marine Skies

The skies that we encounter over the sea can take on a number of forms, like the sea itself. But usually in the vast expanses that cover the oceans, blues will be the predominant colours.

To create the sense of depth required in a scene like this, a cool blue-grey colour needs to dominate. Indigo and Payne's grey work well to create the basic underwash for a windswept ocean sky, giving the impression of distance. Add a little ultramarine to this mixture to create a few 'warmer' patches breaking through the clouds – this complements the blue-greys particularly well, creating a slight visual contrast. The white of the clouds can be 'toned down' a little to create a more natural appearance by the addition of a very dilute wash of raw sienna. The key to using these dominant blues is to use a lot of water and allow them to mix together freely. Apply them with definite, confident brushstrokes and then sit back and allow them to dry without interfering too much with the drying process.

A few 'flashes' of pure, hard edged white paper left to represent the tops of the clouds can be particularly effective in creating 'highlights' in the sky.

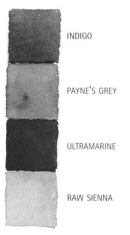

INDIGO

PAYNE'S GREY

ULTRAMARINE

RAW SIENNA

Sea and Sky
In this scene, I set out to capture the sense of movement in both the sea and sky. A combination of dry brush work, wet into wet and vigorous brushstrokes was employed to complete the painting.

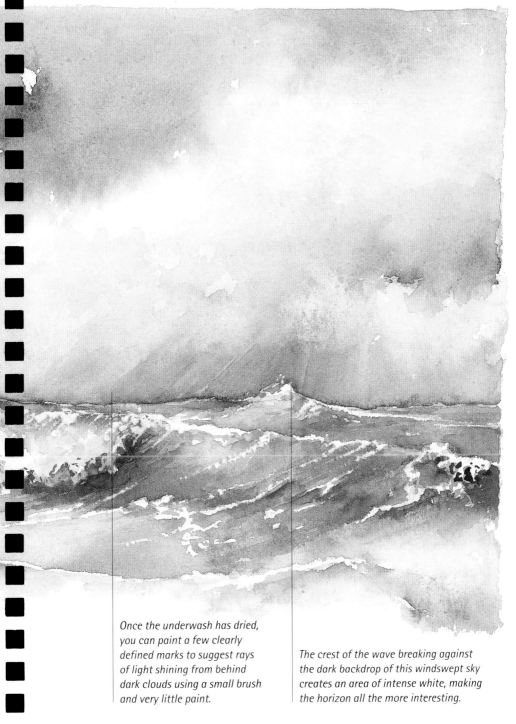

Once the underwash has dried, you can paint a few clearly defined marks to suggest rays of light shining from behind dark clouds using a small brush and very little paint.

The crest of the wave breaking against the dark backdrop of this windswept sky creates an area of intense white, making the horizon all the more interesting.

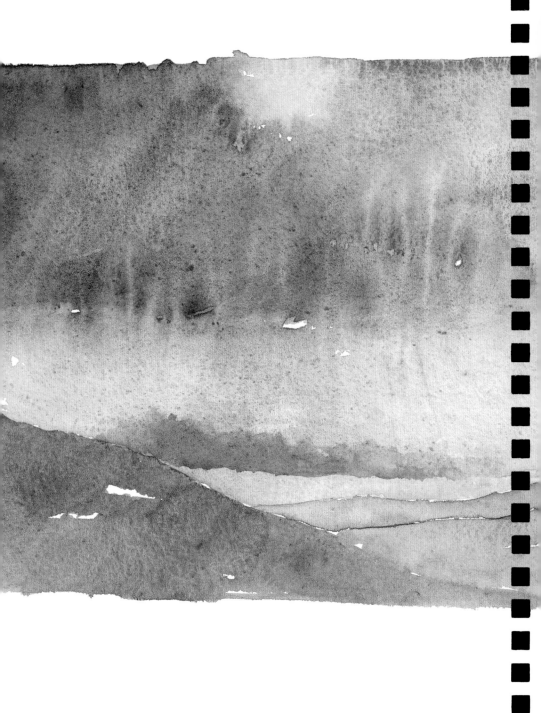

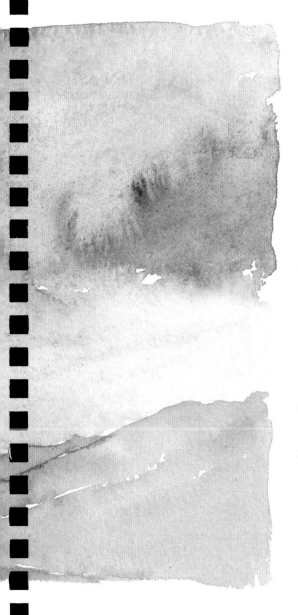

ATMOSPHERIC SKIES

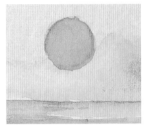

The violet cast, the sienna glow or the orange tinge in skies and clouds are all highly suggestive of changes in the weather. These changes can be quiet, gentle and passive, creating calming sunrises or sunsets. Others, however, can be violent and wild, resulting in storms breaking over the land. You will need to work quickly with a range of colours to capture these special effects.

Natural Blends

The softness of clouds and the variety of tones of colours found in 'atmospheric' skies are created by allowing, or even actively encouraging, paints to bleed, blend and mix together on paper.

Traditionally, colours are mixed in a palette and applied to the paper in their 'ready-mixed' state. This technique has its merits, but can create some rather 'pedestrian' pictures without too much depth. The most exciting way to mix colours is to simply apply paints to damp paper in their 'neat' state and watch them blend naturally. The results can be a little unpredictable – but so can the weather systems that you are painting, so maybe it is quite

The softness of the colour mixes in this early evening seashore scene is the result of allowing colours to work for themselves on damp water-colour paper.

appropriate after all. Should, however, the bleeds not work as you had in mind, you can always blot some of the paint to halt the process, or add more water to encourage the mixes further. The resulting colours will dry with soft, blurred edges and subtle transitions of tone. The choice of how to develop this technique is yours.

COLOUR BLEEDING
Two wet colours placed next to each other on either wet or damp paper will bleed together, naturally finding their own level of mixture and individual drying rates.

WATER BLEEDS
Sometimes, often by accident, water will bleed outwards into a damp colour – this can create a soft, moist effect which is very welcome in an 'atmospheric' sky.

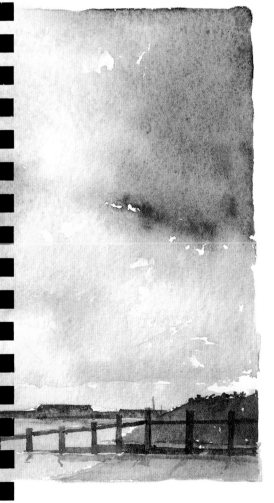

ULTRAMARINE PAYNE'S GREY

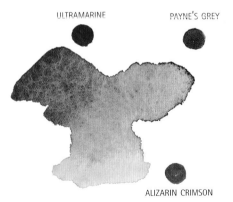

ALIZARIN CRIMSON

SUNRISE

In many parts of the world, little difference exists visually between sunrises and sunsets – both are capable of creating a feeling of great calm as the colours of the sky change to a wealth of warm tones, blending and merging across the horizon.

Sunrises, however, can sometimes be distinguished by the softness of the tones. This is often due to the early morning mists that create a diffusing atmosphere through which the sun's rays must travel before being caught by your eyes.

The soft blending of colours is certainly best achieved by personal organisation of your painting equipment. Choose the colours that you feel you will wish to use and ensure that they are all wet and ready to go. Then, wet the paper evenly with plain water using a large brush, and quickly begin to apply the paints, using a graduated wash technique in the first instance. Then, before the paper has time to begin to dry, introduce the violets, pinks, oranges and other tones by applying those to the wash, using exactly the same technique. If you paint them and leave them, they may dry with a hard line. If, however, you use your brush to really mix the colours in with the initial graduated wash, then they will dry as part of it, creating a range of warm, soft tones, with no perceptible start or end.

ROSE MADDER

RAW SIENNA

CERULEAN BLUE

ALIZARIN CRIMSON

PAYNE'S GREY

Sometimes it can be useful to leave a thin, light line along the horizon to emphasise the difference between the sea and sky – especially where the tones of both are almost identical.

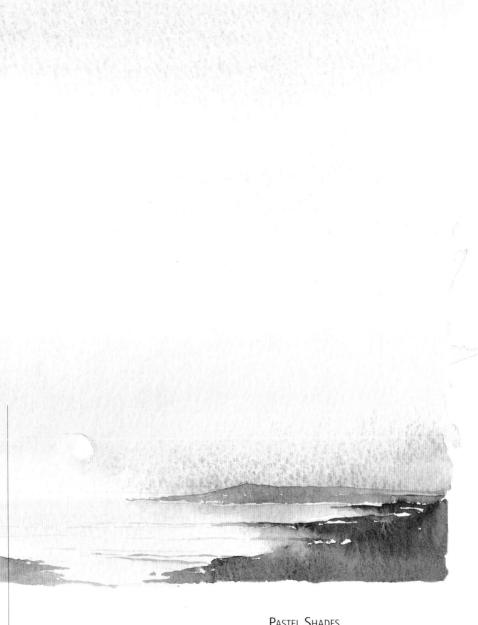

The pastel, chalky tones of the sky in this composition were painted with a lot of water and physical blending with a large brush.

PASTEL SHADES

Pastel shades are best created by applying watery washes of colour onto damp paper and using your brush to work them together on the paper surface.

Early Morning Sun

Staring at the sun is certainly not to be recommended, even when it is soft and diffused by the prevailing atmospheric conditions. When painting sunrises or sunsets, however, you will have to make a decision, based upon a quick impression, as to how you wish to paint the sun – leaving it lighter or painting it darker than the surrounding sky.

As sunrises don't usually allow the sun to fully develop its raging, colourful glare, it is probably best to leave it unpainted, concentrating on the colours in the sky.

The soft, warm grey mist of the early morning sunrise can turn all shapes into simple blocks or grey silhouettes, and is best painted onto an underwash of lemon yellow. As this is drying, apply a wash of alizarin crimson and Payne's grey over the top, ensuring an even coating to achieve the full, misty effect.

To create less murky morning mists, apply a wash of cerulean blue to damp paper. As this begins to dry (that is, when the paper is damp, not wet) paint a wash of alizarin crimson along the horizon and pull it up, using the edge of your paint brush, to meet the cerulean blue. The two colours will blend softly without completely mixing.

Sometimes, the sun will rise, casting a golden glow across the landscape – this is usually short-lived so needs to be captured quickly! To avoid a harsh orange, apply an underwash of raw sienna to damp paper. As this begins to dry, wash a watery mixture of quinacridone gold along the horizon and allow the two strong colours to merge together, creating a soft, warm glow.

Misty Skies
Misty, murky skies often allow a light sun to shine through.

LEMON YELLOW

ALIZARIN CRIMSON

PAYNE'S GREY

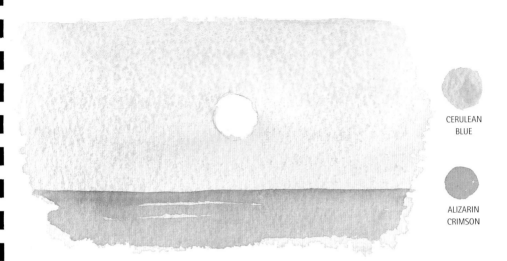

CERULEAN
BLUE

ALIZARIN
CRIMSON

PASTEL TONES

The softness of the surrounding colours allows
the sun to glow with a brilliance of pure white.

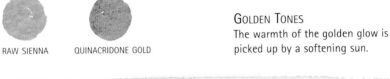

RAW SIENNA QUINACRIDONE GOLD

GOLDEN TONES

The warmth of the golden glow is
picked up by a softening sun.

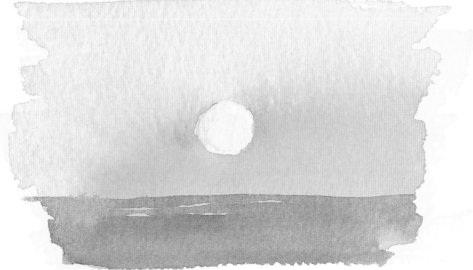

SUNSET

The fiery colours of a sunset need a slightly different approach to the soft pastel shades of the calmer, less intense sunrise.

Whilst the starting point of a graduated wash is still important, the other techniques need to be more dramatic to create the intense colours of the sky.

Unusually, in this picture the graduated wash was started with cadmium orange at the bottom along the line of the horizon, and alizarin crimson at the top of the paper, and the two colours were gradually worked together in the centre. As they were beginning to dry, a mixture of cadmium orange and cadmium red was worked into the middle of the sky, just above the sun, suggesting the strength of its glow as the evening drew to a close.

As these colours began to dry, I mixed the cloud colour of Payne's grey, alizarin crimson and a touch of cadmium red in the palette and applied this using the edge of the paint brush in a sweeping motion across the sky. As the paper was barely damp, only a minimum amount of bleeding took place, allowing the clouds to exist in their own right.

To avoid your sun looking as if it has been cut out and stuck on, apply the paint and then, with a small brush, drop a little water into the centre – this will push the paint outwards, creating a curved effect.

CREATING CLOUDS

When a watercolour painting is thoroughly dry (feel the back of the paper just to make sure) you can create some light, small clouds by rubbing over the dried paint in a diagonal direction with a putty rubber – this removes some of the surface paint.

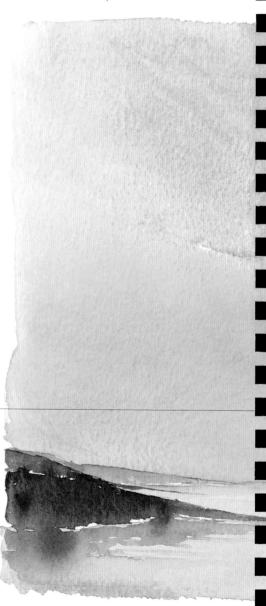

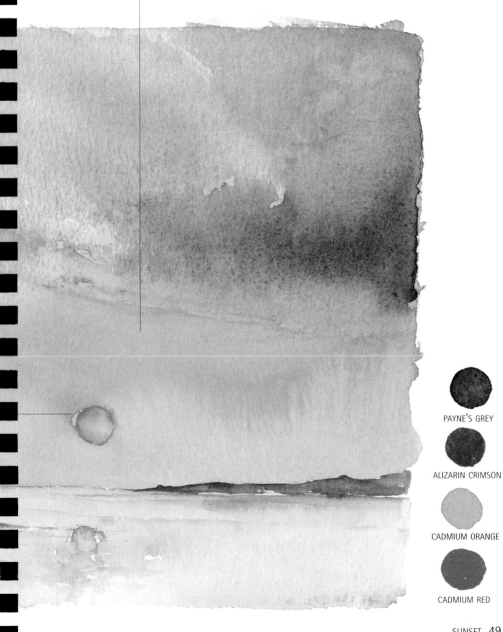

The sky appeared to be on fire when this sunset was painted, with the overall impression being aided considerably by the depth of colour on the underside of the light, late evening clouds.

PAYNE'S GREY

ALIZARIN CRIMSON

CADMIUM ORANGE

CADMIUM RED

LATE EVENING SUN

A colourful sun amidst the glow of a sunset can add an element of visual 'weight' to a composition, intensifying the effect of evening light.

An orange sun is best surrounded by an orange and gold-tinged sky – but remember that the sun is the focal point, so don't make the sky colours too strong. Apply a graduated wash of cadmium orange and quinacridone gold to the sky, then introduce a little alizarin crimson to suggest approaching cloud. Only when the sky colours have dried, paint the sun with a strong mix of cadmium orange, blended with the quinacridone gold on the palette.

A slightly less intense sun can be created using exactly the same background of sky colours, only this time add a little raw sienna to the tones in the sky – this will not look out of place amongst the intensity of the orange and gold paints, rather it will have the effect of 'calming' the tone a little, suggesting a less sharp and clear sky through which your sun is seen. Summer evenings are often hazy with heat.

The intensity and brilliance of a bright red sun is best created by careful mixing of cadmium red and alizarin crimson. It is important that the red is allowed to dominate, so only use a touch of the crimson paint – this will prevent the red from looking unnaturally bright by toning it down a little, but not removing the brilliance of its colour.

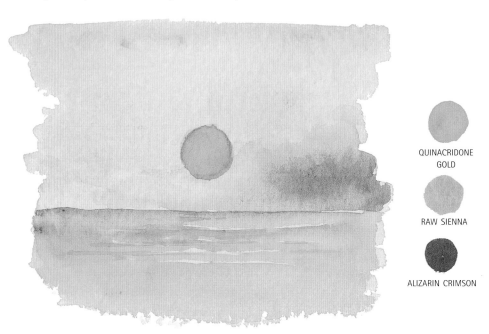

QUINACRIDONE
GOLD

RAW SIENNA

ALIZARIN CRIMSON

DIFFUSED SUN
Atmospheric conditions and mists can easily rob a sun of its strength.

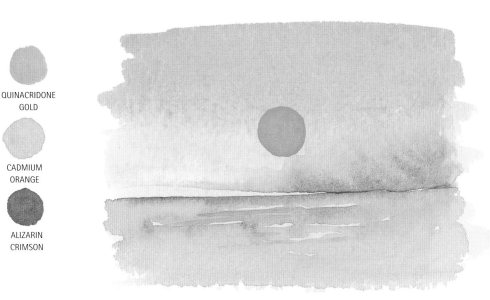

QUINACRIDONE
GOLD

CADMIUM
ORANGE

ALIZARIN
CRIMSON

ORANGE SUN

The intensity of this coloured sun is subdued a
little by the surrounding colours.

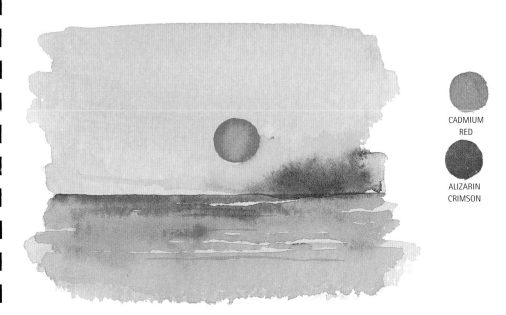

CADMIUM
RED

ALIZARIN
CRIMSON

BRIGHT RED SUN

Sometimes a full-bodied bright red sun burns
away all cloud to glow like a fireball.

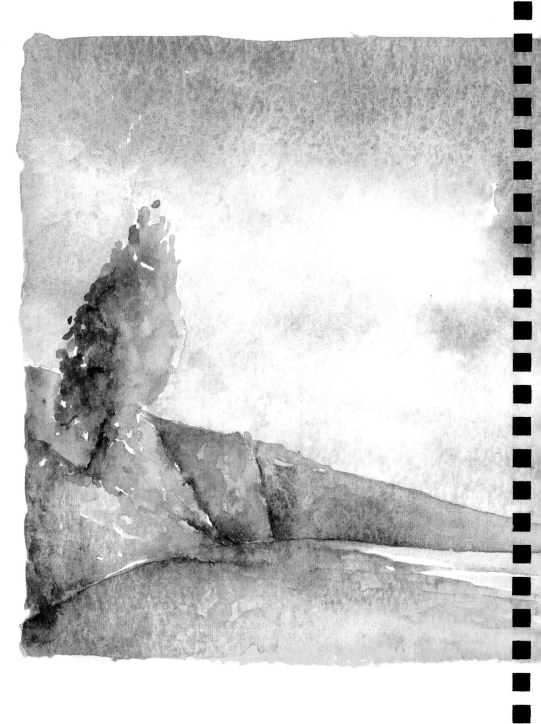

COLOURS

The main tool that any painter has to work with is colour, and understanding how colours work together, with water and on paper, is an essential part of the watercolour painting process. Whilst colours have no physical temperature they are evocative and can be used to suggest both warm and cold environments throughout the seasons.

Cool Neutrals

Grey is a cool, neutral hue – it is not really a 'colour', more of a tone – that can be found in many skies, clouds and cast shadows. It is a useful addition to your palette either as a mixer, or mixed from blues and browns.

The chemically-manufactured Payne's grey is very useful as a 'mixer', creating a base tone to which a vast array of colours can be added to produce a useable, neutral colour for cold-looking skies and clouds.

It is worth experimenting with the application of Payne's grey onto paper before you start to try different colour mixes, to get the feel of the way in which it reacts. Unlike most of the coloured paints featured

Study 2
Working onto dry paper, Payne's grey dries very evenly.

Study 1
Apply pure Payne's grey onto damp paper – watermarks occur very quickly.

PAYNE'S GREY

PAYNE'S GREY

COBALT BLUE

Study 4
Using lots of water mix Payne's grey and cobalt blue together on damp paper. The effect is of rain-laden clouds.

in this book, Payne's grey is a 'dye' based paint and will, therefore, stain paper very quickly. So, on a scrap piece of your normal watercolour paper, try painting Payne's grey onto damp, dry and wet paper to assess for yourself the best way to utilize the physical paint effects created by the varied paper conditions.

Once you are happy that you can predict how the paint will react, experiment with different colour mixes, applying blues and browns to Payne's grey and making some visual notes to remind yourself of the final mixes. Then, move on to mix combinations of blues and browns to see just how many different 'greys' it is possible to achieve.

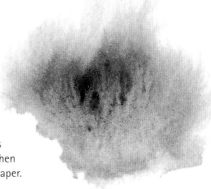

Study 3
Payne's grey becomes very unpredictable when applied to very wet paper.

INDIGO

INDIGO

BURNT UMBER

Study 5
Payne's grey and indigo have a 'flattening' effect together, suggesting a solid bank of rain clouds.

Study 6
Indigo and burnt umber produce a strong 'tobacco' tone, good for stormy skies.

Winter Sky

The cold, blue-grey tones of a winter sky are probably best recorded using a lot of water and a carefully chosen selection of blues, browns and a touch of Payne's grey. This combination can, however, take on a slightly 'flattened' appearance, denying your painting the depth it deserves. This can be counteracted by leaving a small gap along the distant horizon and applying a watery wash of raw sienna to create a distant glow. This effect can be enhanced even more by painting a thin line of alizarin crimson between the raw sienna and the grey cloud colour. If you judge this correctly and apply it when both colours are damp, it will bleed evenly upwards and downwards, creating a soft area of tone connecting the sky and cloud.

When you come to paint the foreground in scenes such as this, it is often a good idea to use the grey used in the clouds for the shadows of objects such as trees and brick walls, as this has a strongly unifying effect on the composition.

Even on a cold, late winter's afternoon, raw sienna can still be used to good effect to create a distant glow on the horizon, acting as a 'visual foil' to the lowering grey clouds.

Siilhouettes

The steely winter light and deep, dark grey clouds throw foreground shapes into little more than silhouettes, without detail, viewed against the cold slate skies.

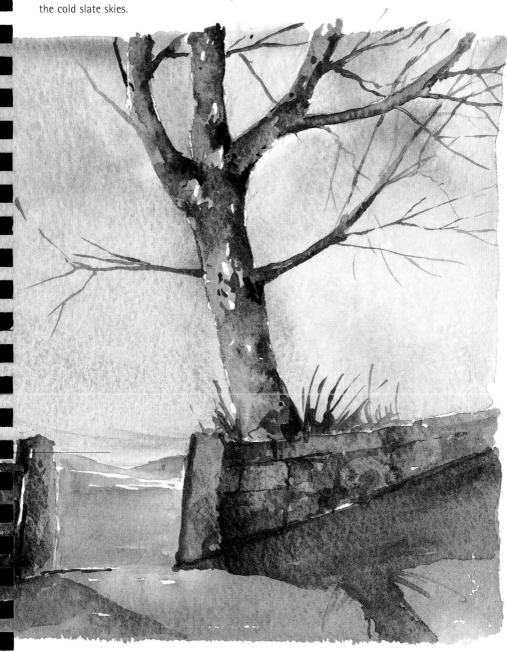

Warm Blues

The idea of 'sky blue' can be as confusing as the concept of grey for painters. With so many blues in art stores to choose from, exactly which ones do you use?

My personal preference for creating a natural, warm blue in skies and clouds is ultramarine. This is a very 'warm' colour, as well as an ideal mixer. Whilst it is a fairly predictable paint, it is always a good idea to try applying it to your normal watercolour paper in various states of wetness to see exactly how it will react.

Most warm summer days will hold more than one tone of blue in the sky, especially if your view covers a vast distance. To paint these scenes, create a graduated wash with ultramarine being the dominant colour washed onto the top of the paper and

Study 1
Apply ultramarine to damp paper and see how long it takes for the watermark to occur without any blending on your part.

Study 2
Painted onto dry paper, ultramarine dries to a smooth finish.

CERULEAN BLUE

ULTRAMARINE

ULTRAMARINE

Study 4
Use ultramarine for the 'weight' at the top of the sky and cerulean blue to create the distance on the horizon.

pulled downwards to blend with the slightly cooler and 'thinner' cerulean blue along the horizon.

It is perfectly acceptable to use ultramarine by itself – this can produce a very strong sky colour, and is also a good base for fair weather clouds over a lake or sea.

The warmest mixture, however, can be created by the addition of a touch of alizarin crimson, pre-mixed in the palette (alizarin crimson also has staining qualities and will not always mix freely with ultramarine on damp paper). A sky wash of ultramarine with just a hint of alizarin crimson works particularly well. To add visual weight to the blaze of clouds, add a little more alizarin crimson and allow it to bleed up into the cloud shape.

STUDY 3
Ultramarine does not react so very differently to wet paper as it does to damp paper – it tends to dry to a 'softer' finish without blending.

ULTRAMARINE

ALIZARIN CRIMSON

STUDY 5
See how far you can take pure ultramarine in terms of tone and strength of colour.

STUDY 6
The introduction of alizarin crimson creates a gentle, warming effect.

Summer Sky

It is a particularly good idea to visit the same site several times during the course of a year to witness the different effect that each individual season has on the surrounding landscape.

The summer skies that hold the warmest of blues are best created by allowing ultramarine to dominate the scene, ensuring that the bulk of the colour appears at the top of the sky. Often, faint wispy clouds will appear in such skies – they are best recorded by pulling the paint in long, sweeping movements from the horizon, diagonally, up towards the corner of the page, ensuring that you leave some white paper showing through to represent the clouds. If too much paint runs into these areas you can always drag a piece of kitchen paper along the line of the clouds and this will remove the unwanted paint, creating a sense of movement in the sky at the same time.

Finally, a little raw sienna can always be added to damp cloud areas to give them a little 'bulk' if the wispy cloud areas look too gentle for your liking.

The use of the light cerulean blue along the horizon helps to create a sense of perspective in the sky, enhancing the effect of distance in the composition.

Visual Weight
It is possible to create a feeling that the top of the sky area is 'pushing' down on the composition, sandwiching the soft summer clouds, by using a particularly strong colour.

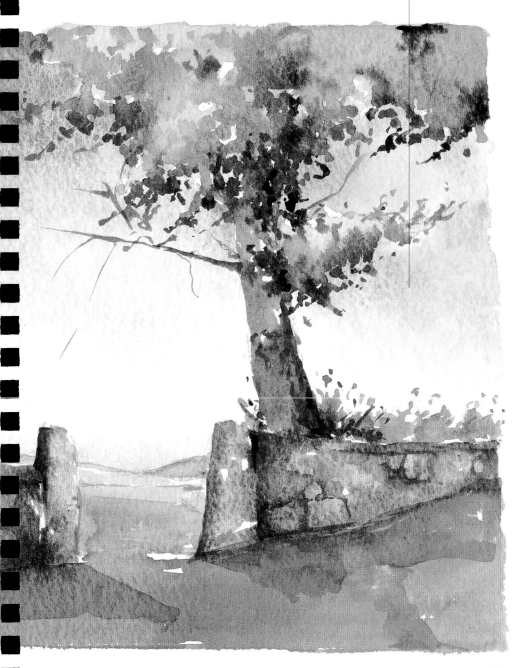

The warmth generated by the summer sky in this landscape is the result of careful use of ultramarine and cerulean blue – allowing one to dominate and the other to recede.

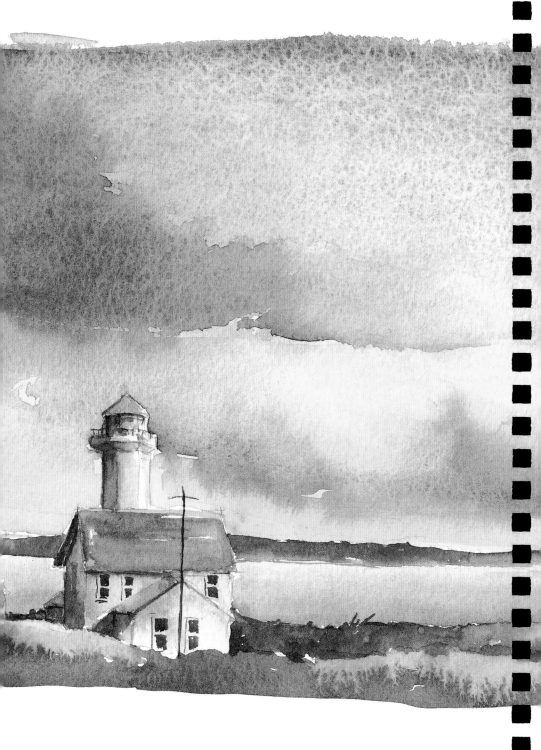

PRACTISE YOUR SKILLS

Different seasons, weather conditions and locations all provide individual skies for you, the artist, to record. The projects that feature in this section are designed to take you step-by-step through the processes that i use to create a 'finished' painting, using a variety of different techniques.

FINE WEATHER

Although fine weather clouds, blue skies and green woodlands may, in terms of colour similarities, seem to be poles apart, it is important when painting to find some unifying tone – in this particular project it was the warmth of the natural earth colour, raw sienna. Watercolour paints are translucent – any colour placed on top of another will be influenced by the first wash to a greater or lesser extent. So, when used as an underwash, raw sienna underpins any colours placed on top.

The use of pure ultramarine in the sky is always a good indicator of fine, balmy days when you can afford to take your time over a painting in the knowledge that you will rarely be interrupted by approaching storms. Ultramarine is also known as a particularly warm blue and can always be used to suggest higher temperatures.

The key theme running through this painting is that it is advisable to become as familiar as possible with the 'colour temperature' of the paints in your box: which colours do you need to create warmth, and alternatively, which colours will help to cool things down a little. A predominantly warm palette will set the overall scene.

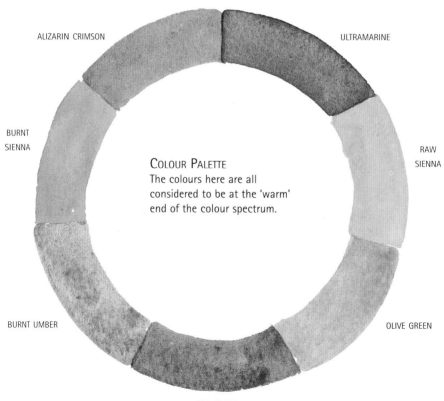

ALIZARIN CRIMSON

ULTRAMARINE

BURNT
SIENNA

RAW
SIENNA

COLOUR PALETTE
The colours here are all considered to be at the 'warm' end of the colour spectrum.

BURNT UMBER

OLIVE GREEN

SAP GREEN

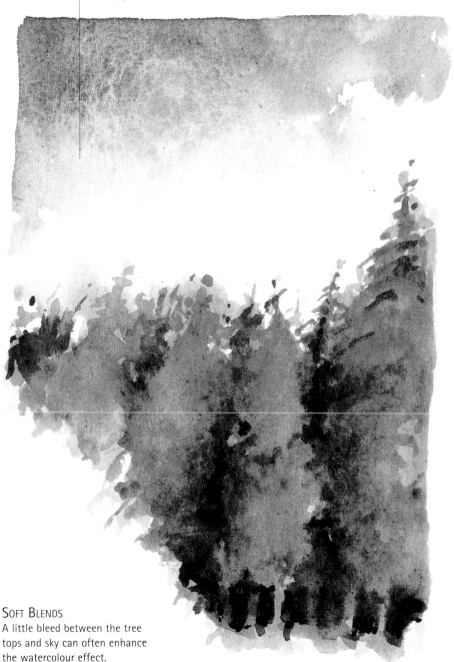

The use of a touch of violet can work particularly well in 'warming up' a sky, although ultramarine usually speaks for itself in this area.

Soft Blends
A little bleed between the tree tops and sky can often enhance the watercolour effect.

Calm Summer Sky

The peace and tranquillity of the 'back-wood' scene in this project was as much due to the soft tones of the sky as the gentle stillness of the trees and the calmness of the foreground.

It was important that the sky and foreground shared a major unifying factor. To link the two areas, raw sienna featured in the clouds and also as the underwash for the trees and hillocks in the foreground.

MATERIALS

- 425 gsm (200 lb) watercolour paper

- Brushes – 1 large (size 12), 1 medium (size 8), 1 small (size 2)

- Watercolour pan paints – ultramarine, raw sienna, olive green, cadmium yellow, sap green, burnt umber, burnt sienna, alizarin crimson

1 *The first stage of this painting was to dampen the paper (not flooding it) to allow the first wash of ultramarine to bleed gently down into the sky area, creating very soft edges in the process.*

2 *Before this could dry fully, I added a very thin wash of raw sienna to the base of the clouds and allowed this to bleed upwards to add a little 'weight' and warmth.*

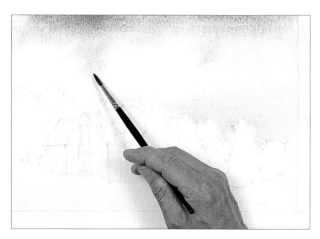

3 *Next, I applied a stronger wash of raw sienna to the line of trees in the middle ground. This bled a little into the sky – but this was quite welcome as it softened the tops of some of the trees, which was in keeping with the atmosphere of the day.*

4 *To start to develop the colours in the trees, I applied a wash of olive green – a soft, thin colour – onto the damp underwash, allowing the paint to create some shapes in the foliage for me.*

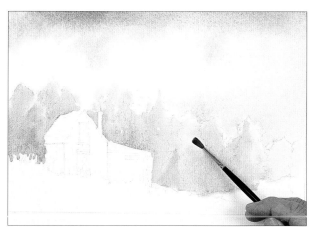

5 *Again, working quickly onto damp paper, I used a small brush to drop some cadmium yellow onto the tops of the trees, reinforcing the light from the summer sky catching the highest points of their boughs.*

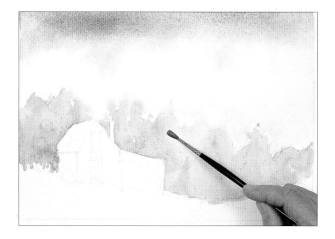

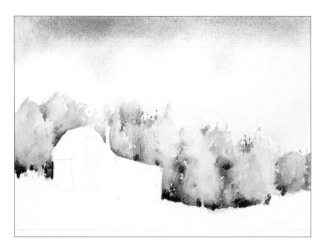

6 With the main 'underwash' now complete, I could start to develop the deepest tones to push the lighter ones forward. Using a small brush and a mixture of sap green and ultramarine, I worked along the base of the trees where the deepest shadows would be. *INSET:* I used the shadow wash to define the shapes of the trees.

7 With the middle ground now complete, I needed to establish an underwash for the foreground. A raw sienna wash was applied to damp paper, then, using a graduated wash technique, olive green was pulled upwards from the base of the paper and allowed to dry.

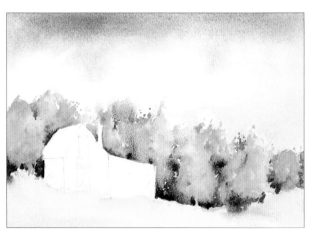

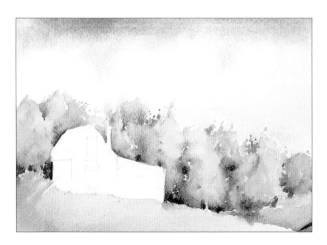

8 The two hillocks had to be defined using the darker green mixture (sap green and ultramarine) to paint the furthest one. This was one of the few times in this picture when hard lines were encouraged.

9 With the foreground dry, careful attention could be given to the shadows cast by the warm summer sky. These were mixed with ultramarine and alizarin crimson and painted across the cabin and the foreground.

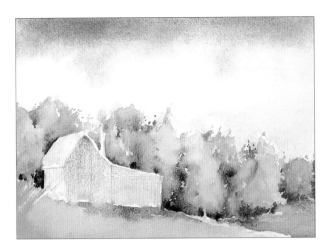

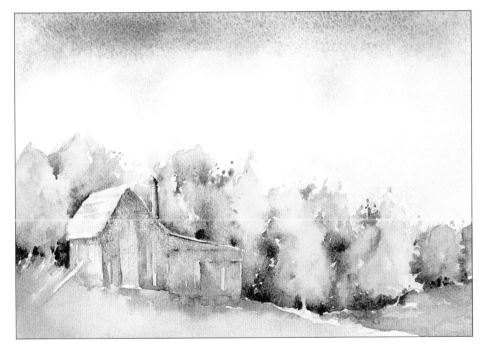

10 The final stage was to complete the detail on the cabin using a mixture of ultramarine, burnt umber and burnt sienna, reinforcing the ultramarine and alizarin crimson in the process.

A Still Day

The softness and warmth of both sky and ground was achieved by choosing the right colours for the job – ultramarine for the main sky colour, and an underwash of raw sienna. The lack of movement in the sky, suggesting a calm, windless day, was created by allowing the paint in the sky to find its own way on damp paper and by not introducing any directional brushstrokes.

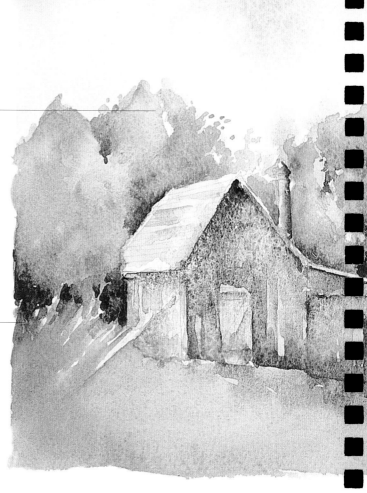

Bleeds from the foliage into the sky areas were not blotted out, allowing a 'hazy' edge to the tops of the trees, reinforcing the 'summery' feel of the scene.

The shadow colours were mixed using the main sky colour (ultramarine) to cement the sense of visual unity.

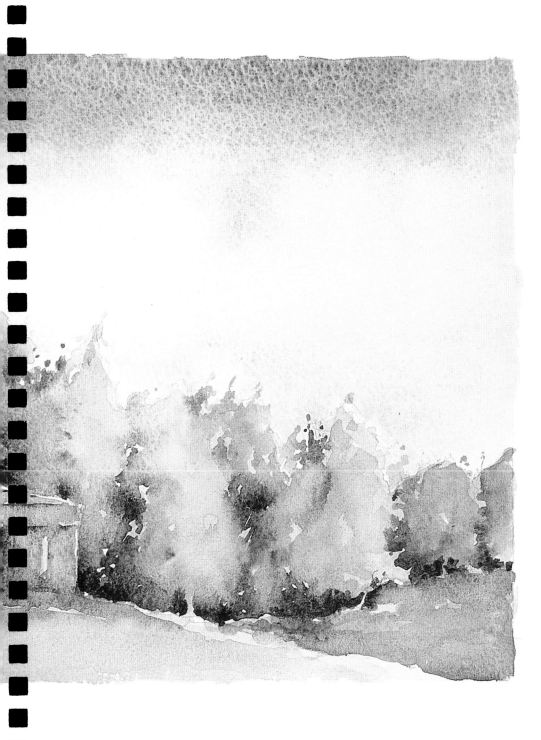

Moving Clouds

One of the most amazing aspects of painting is the way in which the extended use of colour can actually create the impression of physical movement – as is the case in this particular project.

By choosing the correct colours, and placing them with some space in between, it is possible to suggest that the space is being visually squeezed. Two identical colours will not have the same effect in creating that sense of pressure. So, choose a warm, dark blue, such as ultramarine, along the top of your sky area; a light, cool blue, such as cerulean, along the horizon line; and the area in between can be transformed into the suggestion of a moving cloud.

The transformation does involve using specific brushstrokes to indicate the direction of the clouds – a diagonal brushstroke is usually highly effective. If this is done on damp paper you will be able to create a soft, hazy cloud movement. If you choose to wait until the sky is dry, your clouds will take on a very clear shape as they will probably dry with a hard line. The final option is to use a piece of kitchen paper and drag this diagonally across your damp sky to create white cloud shapes.

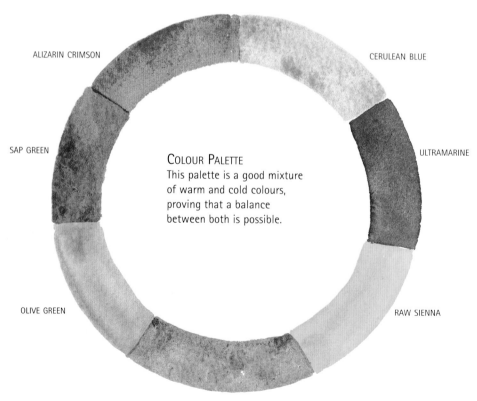

ALIZARIN CRIMSON

CERULEAN BLUE

SAP GREEN

ULTRAMARINE

Colour Palette
This palette is a good mixture of warm and cold colours, proving that a balance between both is possible.

OLIVE GREEN

RAW SIENNA

BURNT UMBER

LIGHT ON DARK

Negative shapes can be particularly effective in creating movement if kept thin and 'wispy'.

The more colours that you can blend into your sky, the better the final result will be and the greater the sense of 'space' in the atmosphere.

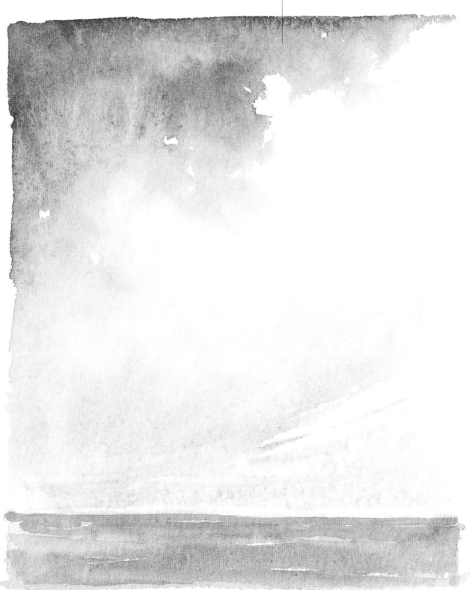

Windswept Sky

Creating a sense of movement in skies does involve an element of movement on the part of the painter. I found that it was necessary to pull paint across the paper, blot sections, and generally be a little more agile than when painting the more gentle, still summer skies.

This picture also used more colours in the creation of the sky, suggesting a level of atmospheric activity by the extended use of paint.

MATERIALS

- 425 gsm (200 lb) watercolour paper

- Brushes – 1 large (size 12), 1 medium (size 8), 1 small (size 2)

- Watercolour pan paints – cerulean blue, ultramarine, raw sienna, burnt umber, olive green, sap green. alizarin crimson

- Kitchen paper

1 *The first stage in this painting was to dampen the paper across the sky area and to run a 'line' of cerulean blue along the horizon with a large brush, raising the brush a little towards the end of the wash, creating some 'wispy' areas of cloud.*

2 *Quickly, a wash of ultramarine was run along the top of the paper and allowed to bleed downwards, 'sandwiching' the main bulk of the cloud area in between.*

3 Before the paper had dried, I took a piece of 'scrunched up' kitchen paper and blotted the top of the emerging cloud area, creating a sharp white edge to clearly define the cloud shape and size.

4 To reinforce these highlights even more, I used a watery mix of ultramarine and alizarin crimson to gently wash around the highlight and, using the edge of the medium paint brush, pulled this down onto the still damp middle cloud area.

5 The sky was now starting to look as if some activity was occurring, but the clouds still needed 'bulking out' a little to increase their visual 'weight'.

6 To achieve this, I took a watery mixture of raw sienna and painted this along the cloud base, pulling the paint upwards, following the first cloud shapes created by the cerulean blue, reinforcing the sense of movement along the horizon.

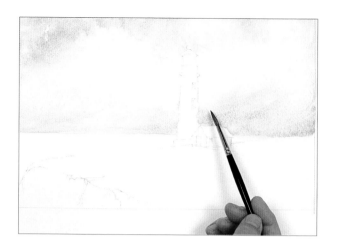

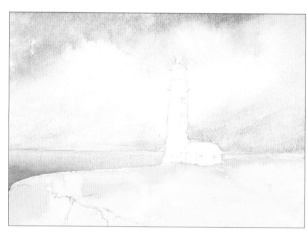

7 Having fully established the form and tone of the sky, the foreground now needed to be developed. The sea was painted using the same colours as in the sky and the foreground was given a watery underwash of raw sienna.

8 The detail and shading on the curved lighthouse was painted with a small brush, using the same ultramarine and alizarin crimson mix used in the sky, creating a sense of visual unity.

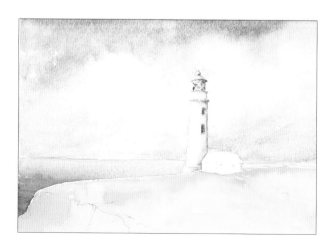

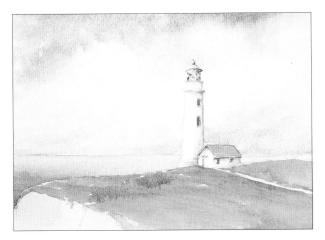

9 *A wash of olive green and sap green was applied on top of the foreground underwash, using broken brushstrokes to allow the raw sienna to show through in parts. The cliff face was painted using mixtures of ultramarine and burnt umber.*

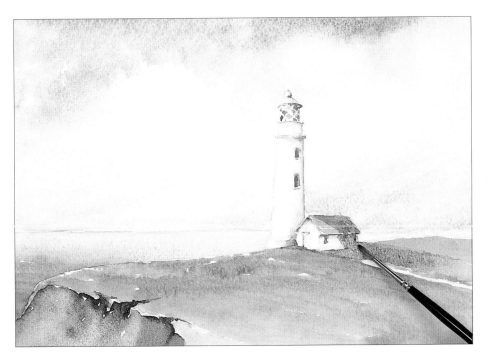

10 *The final stage was to paint the shadows cast onto the ground by the active sky. This, again, was done using a small brush for accuracy and a mixture of ultramarine and alizarin crimson.*

CONTROLLED COLOUR

The key to this picture was the controlled use of a variety of colour in the sky, but also not being afraid to have many large sections of white. The contrast between the soft areas of cloud at the top and the more clearly defined brush marks along the horizon help to create the sense of direction and movement in this summer sky.

Raw sienna is best used at the base of the cloud to create a sense of weight in summer skies – too much grey or violet can make them look stormy.

The thin line of cerulean blue visually pushes the clouds forward in the composition increasing the effect of distance across this vast vista.

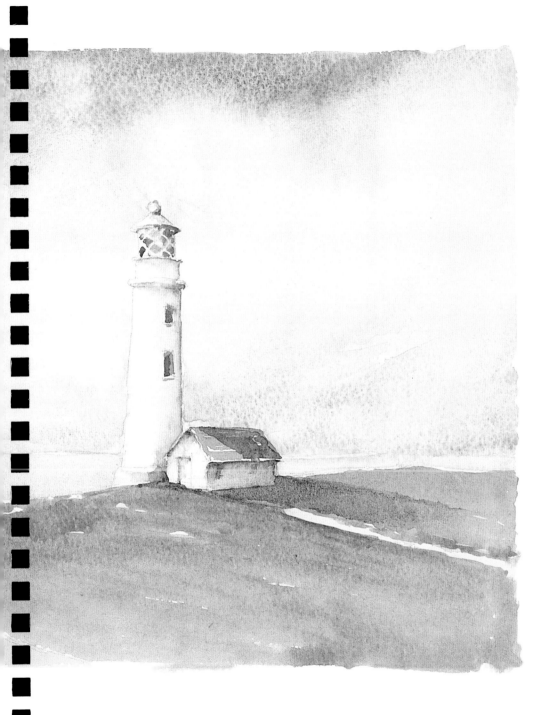

Sunrise over Water

As the sun rises over water, burning away the early morning mists, magnificent things can occur above the horizon. Oranges blend with purples and violets, catching the tops of clouds and creating fiery glows and pastel shades side-by-side.

Sunrises are usually different to sunsets - they are often softer, calmer and considerably more relaxing. The colours tend to be more localized, rarely flooding the sky with violent hues – more bathing them in an early morning glow.

To create these colours it is advisable to add very strong colours to very wet paper – this has a two-pronged effect. First, it will dilute the colours quickly so they will take on the softer appearance of an early morning sunrise. Second, they will bleed and blend quickly, creating a range of tones that you probably would not think of mixing on your palette. These too will dilute and dry to some delicate pastel shades, but without the hard edge you would find if you tried to mix them yourself and paint them onto dry paper.

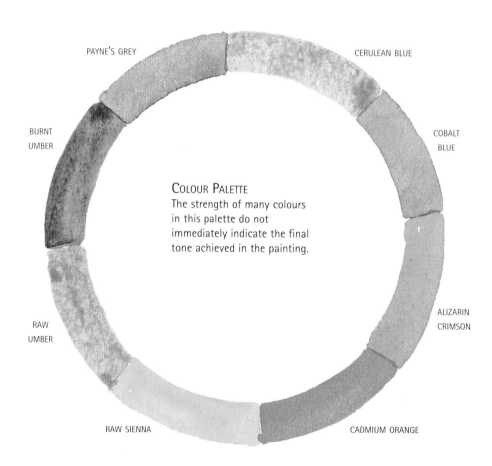

PAYNE'S GREY

CERULEAN BLUE

BURNT UMBER

COBALT BLUE

Colour Palette
The strength of many colours in this palette do not immediately indicate the final tone achieved in the painting.

ALIZARIN CRIMSON

RAW UMBER

RAW SIENNA

CADMIUM ORANGE

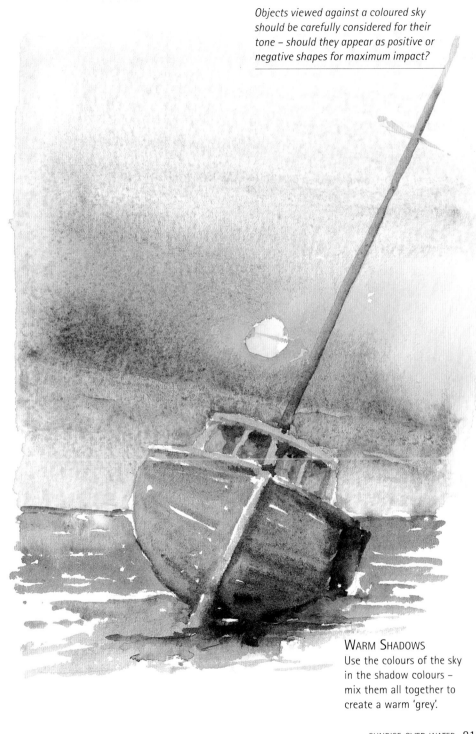

Objects viewed against a coloured sky should be carefully considered for their tone – should they appear as positive or negative shapes for maximum impact?

WARM SHADOWS

Use the colours of the sky in the shadow colours – mix them all together to create a warm 'grey'.

ESTUARY SUNRISE

The speed with which the sun rises over the horizon can be alarmingly quick for painters – the colours left in its wake, however, remain for longer, allowing us a little more time to consider how best to record them.

Although the weather was clement, I relied heavily on the colours at the 'cool' end of the spectrum to paint this passive estuary sunrise.

> **MATERIALS**
>
> • 425 gsm (200 lb) watercolour paper
>
> • Brushes – 1 wash brush, 1 large (size 12), 1 medium (size 8), 1 small (size 2)
>
> • Watercolour pan paints – cerulean blue, cobalt blue, alizarin crimson, cadmium orange, raw sienna, raw umber, burnt umber, Payne's grey
>
> • Masking fluid in applicator • Putty rubber

1 *Having masked out the sun and boat mast which crossed the main sky area, I washed water onto the paper using a wash brush and ran a wash of the cool cerulean blue along the top of the page and pulled it downwards to the horizon.*

2 *While this was still wet, I mixed some alizarin crimson with a touch of the cooler cobalt blue and pulled this paint in two lines across the centre of the sky, 'sandwiching' a space in between.*

3 Working quickly now, I mixed up a little cadmium orange and painted this onto the damp paper between the two violet-purple lines, creating an orange glow, suggesting the bright light emitted by the rising sun.

4 Before the sky was finally allowed to dry, I returned to the violet and ran the specific shape of a light, early morning cloud directly under the sun – take care not to paint clouds behind the sun, that's not possible! Once the wash had dried, I gently removed the masking fluid with a putty rubber.

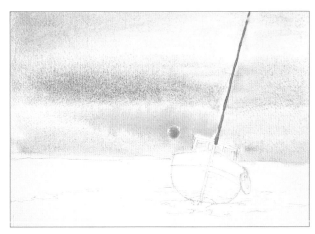

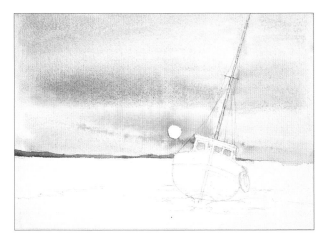

5 The bank on the far side of the estuary was painted next using a touch of Payne's grey and the orange and violet that were now sitting in the palette, creating a warm grey.

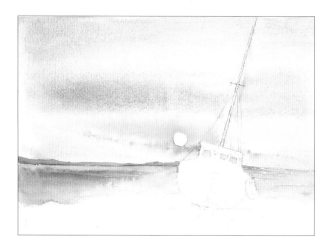

6 *The water was painted in a similar way to the sky - the paper was dampened and the sky colours were pulled downwards across it, starting with cerulean blue and adding the violets closer to the foreground.*

7 *The wood of the boat was created by mixing raw sienna with a touch of burnt umber and a little of the 'palette violet'. Using a small brush, I picked out a few wooden planks to suggest the fabric of the hull.*

8 *To reinforce the nature of the early light, I added some shadows to the hull of the boat using Payne's grey and violet, darkening the side and bottom.*

9 *The sand was painted using a watery mix of raw umber. This was painted onto dry paper at first, to allow the rivulets of water that gently lapped the shore to develop.*

10 *The final stage of this project was to paint the reflection from the boat and sky in the foreground puddles, using watery versions of all the colours used in the entire picture. I also added a very watery wash of cadmium orange and raw sienna to the sun and gave some definition to the mast with a thin wash of burnt umber.*

Subtle Light

The use of Payne's grey, mixed with oranges, blues and violets, contributed greatly to the success of this picture. It is best only used when the lighting produces slightly flat images, such as sunrises or sunsets.

Masking fluid also proved to be useful as it allowed the sky to be created freely without having to work around the mast, or darken it by painting over it – it now maintains its light tone, contributing to, rather than dominating, the composition.

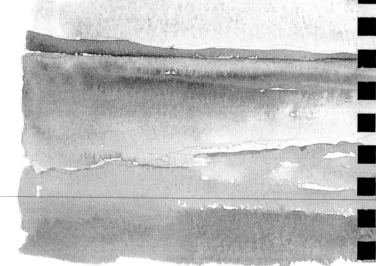

Having removed the masking fluid from the sun, a little soft toning was applied to prevent the glare appearing too strong.

Even the reflections from the boat are created using all of the colours used in painting the sky.

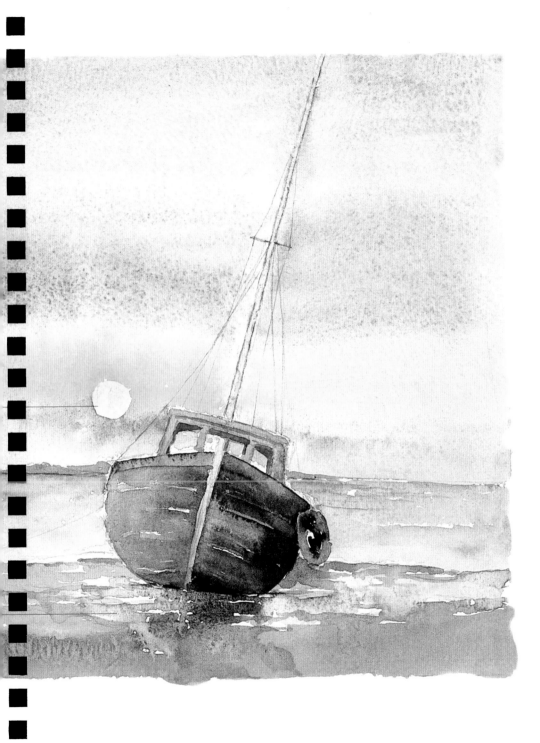

Mountain Storm

Whilst it would not be everyone's choice to be caught in the maelstrom of a raging mountain storm, it can be the most awe-inspiring, memorable experience.

The reality is that few people would stop in such a situation, take out a sketch pad and watercolours, and begin to paint. This is where visual memory becomes important. Artists develop a critical eye for the world around them, with the ability to recall shapes and colours. This is what you need to do when beginning a project involving extreme weather that you have experienced at first hand – recall the colours and apply them to the scene you wish to paint.

Hail, rain or snow can be created by the use of masking fluid, but the final result of thousands of specks of white paper will only work effectively if you ensure that the colours you apply to the sky are really strong. As they will need to blend naturally onto wet paper which will have the effect of diluting your chosen colours, you will have to ensure that the colours you apply are considerably darker than your anticipated end result.

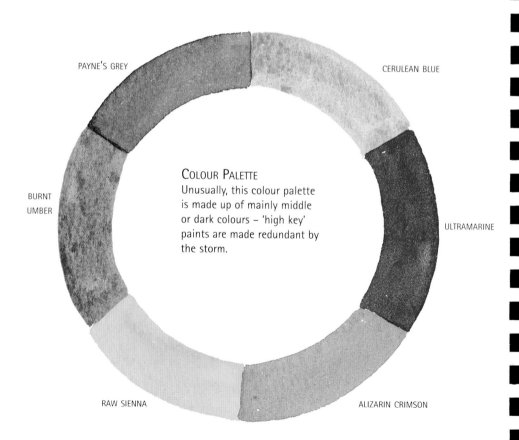

PAYNE'S GREY

CERULEAN BLUE

BURNT UMBER

ULTRAMARINE

Colour Palette
Unusually, this colour palette is made up of mainly middle or dark colours – 'high key' paints are made redundant by the storm.

RAW SIENNA

ALIZARIN CRIMSON

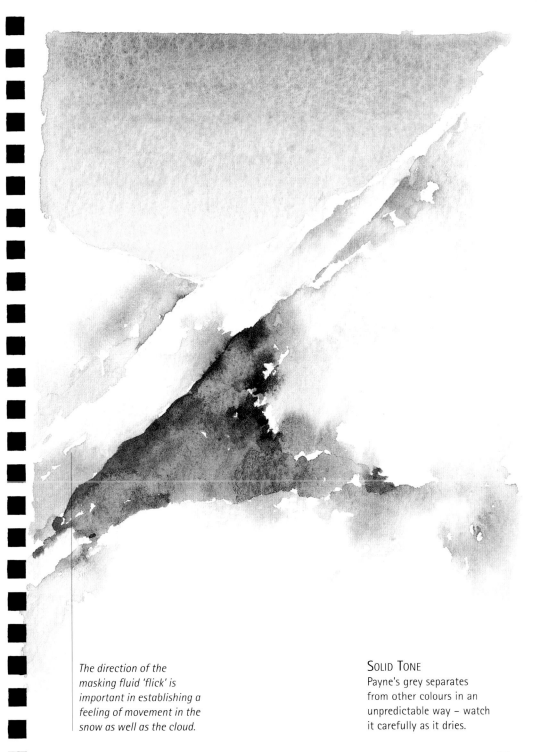

The direction of the masking fluid 'flick' is important in establishing a feeling of movement in the snow as well as the cloud.

SOLID TONE
Payne's grey separates from other colours in an unpredictable way – watch it carefully as it dries.

SWIRLING SNOW

The high mountain passes are inspiring places to walk, even in the face of a raging storm. This project relies heavily on capturing the image of swirling clouds and driving snow on water-colour paper.

The colours chosen for use in the sky are the result of impressions gained from the experience – not from studied observations that would have been impractical in the circumstances.

MATERIALS

- 425 gsm (200 lb) watercolour paper
- Brushes – 1 wash brush, 1 large (size 12), 1 medium (size 8), 1 small (size 2)
- Old toothbrush
- Masking fluid • Putty rubber
- Watercolour pan paints – Payne's grey, burnt umber, cerulean blue, raw sienna, ultramarine, alizarin crimson
- Kitchen paper

1 *The first stage of this painting was to load an old toothbrush with masking fluid and flick this vigorously across the paper. I did this several times to create a variety of marks – small specks and larger droplets. This was left to dry.*

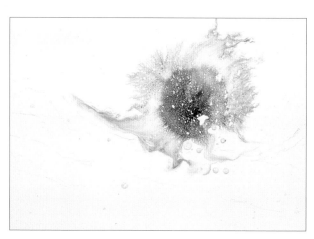

2 *Next, I flooded the sky area of the paper with water using a large wash brush and applied a very watery mix of Payne's grey. This instantly spread out across the paper and around the masking fluid.*

3 Before the paper could dry, I applied some watery burnt umber to the top of the composition and watched as the colours ran into each other, creating a variety of stormy and subtle tonal mixes.

4 The final step in creating the sky was to apply some watery raw sienna and allow that to mix with the other paints, creating more colours and tones than I could ever have achieved in my palette.

5 As the very watery paint was beginning to dry onto dry paper, the creation of a hard line was likely, so I blotted the outer edge with a piece of kitchen paper to soften the effect, reinforcing the 'misty' feel of the foreground.

6 With the sky area drying, I could now begin to concentrate on developing the foreground. Using a small brush and a pale mix of ultramarine and Payne's grey, I painted the rock under the snow in the middle ground.

7 The middle ground was completed by developing the rock and snow on the right-hand side. This was done by dampening the snow area and applying a mix of burnt umber and Payne's grey underneath – the colour bled up into the snow, softening the edges.

8 The foreground rocks were painted in the same way, using a medium size brush to avoid a set of 'fussy' brushstrokes. To create the effect of shading on the snow, a light violet was mixed from cerulean blue and alizarin crimson and washed onto some of the snow.

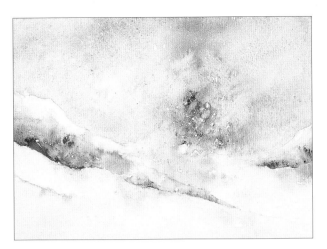

9 *The light violet was used to add definition to the snow field in the immediate foreground. The piles of snow that had been created by the wind cast slight shadows – these were painted onto damp paper.*

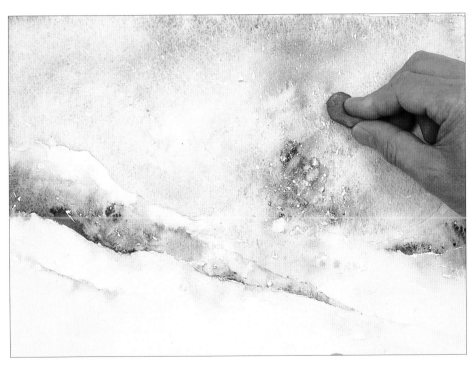

10 *The final stage of this painting was to check that the paper was completely dry and then to remove the masking fluid by working gently over the surface of the picture with a putty rubber.*

ABSTRACT SHAPES

The final picture holds some near-abstract qualities in the sky – but this is held firmly in check by the rocks and cliffs in the middle and foreground.

The white specks of paper representing snow are the direct result of extensive use of masking fluid. The effect works because the sky colours are dark enough to make them stand out. A pale, watery sky would not be so successful.

The variety of white flecks adds a sense of perspective and distance to the scene – these will occur naturally as you flick the masking fluid.

The soft violet tint to the foreground snow also allows the masking fluid to work effectively – when removed, the white still shows even against such gentle toning.

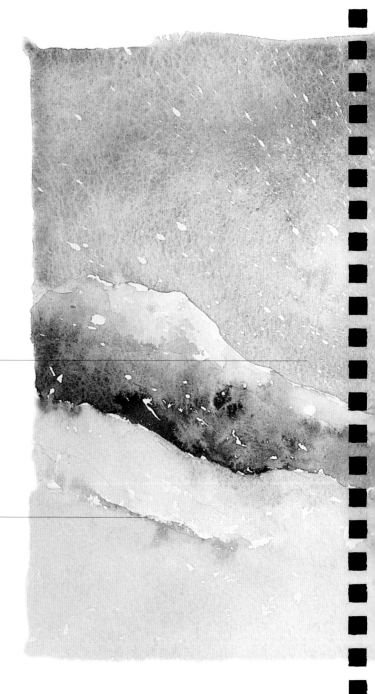

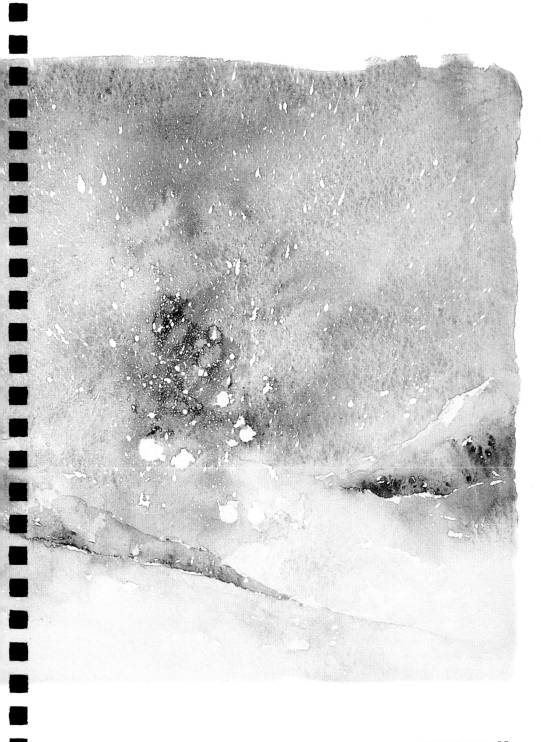

INDEX